HANS HAACKE 1967

This catalogue accompanies the exhibition *Hans Haacke 1967*
MIT List Visual Arts Center
Cambridge, MA
October 21–December 31, 2011

Curator: Caroline A. Jones

Support for *Hans Haacke 1967* has been generously provided by the Barbara and Howard Wise Endowment for the Arts, the Council for the Arts at MIT, the Massachusetts Cultural Council, and Consulate General of the Federal Republic of Germany.

masssculturalcouncil.org

ISBN: 978-0-938437-77-2

Front cover: *MIT Sky Line,* 1967; back cover: *Flight*, 1967
Opposite: Visitors at Hans Haacke's exhibition at the Hayden Gallery, MIT, 1967.

Unless otherwise noted, all photographs are taken by Hans Haacke and are published here courtesy of the artist.

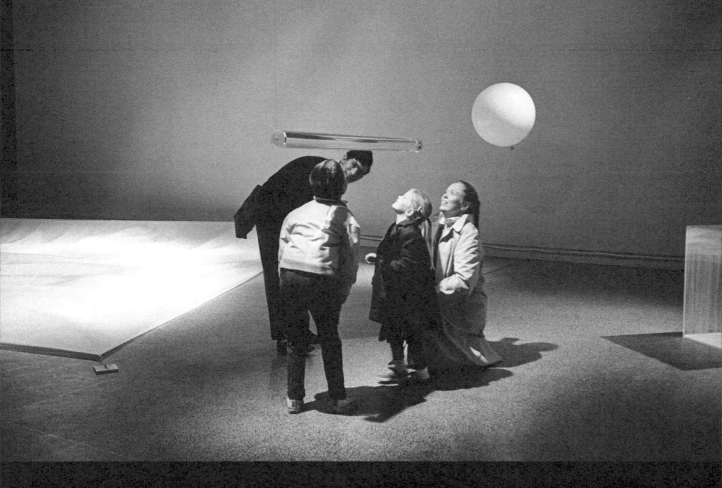

ACKNOWLEDGMENTS

Throughout the past year, as the Massachusetts Institute of Technology celebrated its 150th anniversary, the MIT List Visual Arts Center has presented a series of exhibitions that bring to light the Institute's extraordinary artistic heritage. This re-presentation of Hans Haacke's 1967 MIT solo exhibition is a fitting piece of this exploration.

Hans Haacke has been a force in the artworld for five decades, and it has been our pleasure to work with him to restage these early works that utilize such elements as earth, air, and water. He has kindly opened up his home and archives for multiple visits, graciously providing objects, images, and records.

The idea for *Hans Haacke 1967* began with a visit by former List Center director Jane Farver to Haacke's 2008 exhibition at Paula Cooper Gallery in New York City. Realizing that the artist, whom she had known for years, was taking photographs in the gallery, they chatted and she learned that Haacke had first shown some of the work at MIT decades earlier. He sent photographs to Farver, who shared them with MIT art historian Caroline Jones, who set about to determine exactly what had been shown in the original presentation.

We are so grateful to Jones, who is Director of the History Theory + Criticism of Art and Architecture program in MIT's Department of Architecture, for her extensive research, writing, and sheer enthusiasm in organizing this exhibition and catalogue, which includes not only the works seen at MIT in 1967 but a selection of photographs of Haacke's systems works produced around that time. This is the third project Jones has so generously undertaken with the List Center.

List Center Gallery Manager Tim Lloyd, who makes every exhibition look its best, spent months making sure the various components of these works, many of which needed to be refabricated, came together seamlessly. He was assisted by Alexander Hilton Wood, an MIT graduate student in History Theory + Criticism, who used his interests and skills in research, computer-aided design, and project management to bring this project to completion, and Meegan Williams, who used her considerable skills on several of the silk pieces. MIT graduate student S. Faisal Hassan provided invaluable research assistance for the curator, as did MIT Museum archivist Laura Knott.

This catalogue includes the first English-language publication of Edward Fry's essay on Haacke that was intended for the canceled Guggenheim exhibition of 1971. Caroline Jones was able to track it down at the University of Pennsylvania Special Collections with the assistance of Aaron Levy, Executive Director of Slought Foundation. We appreciate the permission of Sandra May Ericson and the Fry estate to publish it here. This publication was ably edited by Joseph N. Newland, Q.E.D., and designed by Jean Wilcox of Wilcox Design.

Special acknowledgment is also offered to the generous lenders of art, including the artist; Paula Cooper Gallery, New York; the Art Gallery of Ontario; and the MIT Museum.

Funding for *Hans Haacke 1967* has been generously provided by the Barbara and Howard Wise Endowment for the Arts, the Council for the Arts at MIT, the Massachusetts Cultural Council, and Consulate General of the Federal Republic of Germany.

I owe a great debt of gratitude to my List Center colleagues, who are skilled professionals who handle their roles so well. To Registrar Diane Kalik, Educator and PR Officer Mark Linga, Gallery Manager Tim Lloyd, Gallery Assistant John Osorio-Buck, Administrative Assistant Barbra Pine, Curator João Ribas, Public Art Curator Alise Upitis, Web Assistant Dani LaFountaine, Gallery Attendants Karen S. Fegley, Magda Fernandez, Kristin Johnson, Bryce Kauffman, and Suara Welitoff, and interns Jill Fisher, Alex Jacobson, Beryl Lam, Emily Manns, Megan Reinhart, Andrea Rosen, Shelby Spaulding, and Angelina Zhou, thank you so much for your dedication and hard work to make *Hans Haacke 1967* such a success.

And lastly a heartfelt thank you to former director Jane Farver, for initiating this project and teaching me so much about museums and the arts.

David Freilach, Acting Director
September 2011

HANS HAACKE 1967

CAROLINE A. JONES

RECONSTITUTING "SYSTEMS ART"

Hans Haacke 1967 has three goals: to provoke a reconsideration of late sixties "systems art" in general, to reposition Haacke as a key participant in that discourse, and to re-invent the 1967 exhibition of his systems art at MIT. Each "re-" signals a vexed relation to both past and present. First, systems thinking has become so pervasive that it is difficult to see how instrumental it was to what we now refer to as "relational," "situational," and "social" modes of art-making. Second, Haacke's involvement in non-human systems has been occluded by his own social turn, codified after the trauma of the Guggenheim Museum's cancellation of his planned one-person show in 1971 and canonized as institutional critique. Third, the reconstruction of any historical exhibition is fraught, despite the proliferation of "restagings" in these first decades of the twenty-first century.[1] As curator Bill Arning warns, "what we cannot reconstruct is the technological innocence of the original audience for this work."[2]

Comprehending Haacke's systems thinking in its full historical moment, and installing that "moment" in an exhibition in 2011 may be impossible—but that merely fuels my polemic: the work shown at MIT in 1967 was significantly *different* from the highly social work to which the artist turned shortly thereafter. There is a widespread presumption that Haacke's systems art was merely the trial run for later institutional critique. I propose instead that *Hans Haacke 1967* looks back to a last, exquisite apogee of techno-utopianism. In 1967, "natural" systems would be captured for art with an elegant minimum of technology in order to eradicate sentiment and contemplate non-human agency.

If the work from this time embraced the non-human, it did so in order to minimize the traditional exclusivity of "fine art," which seemed to require an education in the humanities. The viewer's participation was actively solicited, even though the "systems" being investigated were not (yet) social ones. *Hans Haacke 1967* itself results from the broader social systems we now understand to be an incontrovertible aspect of art's work. As recounted in David Freilach's catalogue acknowledgments, it was Haacke's chance encounter with Jane Farver in 2008 that reminded us of his 1967 MIT exhibition. When I proposed to restage it, just what "it" was became an open question. An answer of any kind would have been impossible without the artist's patient collaboration, deep archives, and installation photographs; also crucial was the intense intellectual and material involvement of Alexander Wood and S. Faisal Hassan (fabrication and research assistants, respectively) as well as the gallery's superlative exhibition designer Tim Lloyd.[3] Just what *was* in Haacke's one-person show, which opened on October 24, 1967, at MIT?

Haacke's exhibition had no thematic title.[4] Organized by Department of Architecture professor Wayne Andersen, newly hired to chair MIT's Committee on the Visual Arts, it was intended for MIT students as well as a wider public. Its unorthodox objects—bubbles sliding through a large water level, immiscible liquids sloshing between Plexiglas sheets, "rain" percolating through small holes in transparent plastic acrylic, silk chiffon flowing in ribbons and waves, a parachute suspended in air, a "weather cube"—were like no art these viewers had seen before. Yet Haacke's works gave impetus to a century-long

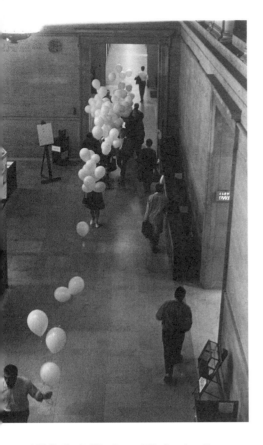

MIT Sky Line, in Killian Court at MIT prior to launching, October 24, 1967.

aspiration of MIT designers: to transform academic Beaux-Arts traditions (chiaroscuro, rendering, the sketch) through protocols of engineering (structural analysis, material innovation, mechanical drawing). This desire was at its most intense immediately following World War II, when Gyorgy Kepes was brought in to reform teaching of "the Drawing,"[5] replacing the pencil with a wide range of technological media, and confirming the Institute's broad goal after the war to ameliorate fears of the technologies its own faculty had made possible (radar no less than the atomic bomb).[6] These years witnessed MIT's founding of a new school of humanities, arts, and social science, an ecumenical chapel, an art gallery, and altogether new curricula in architecture—all part of the growing consensus that technology alone could not solve the problems humans were creating.[7] Haacke was brought into this context, his presence brokered by MIT's architecture school, founded a century before to meld "fine art . . . and technological science,"[8] which resonated nicely with an exhibition of "systems art."

In that brief moment before the student-led revolts of 1968, Haacke's air and water works opened at the Institute's Hayden Gallery, even as the artist's mentors, Zero Group[9] artist Otto Piene and "Systems and Art" theorist Jack W. Burnham, were planning to arrive as the first generation of fellows at MIT's new Center for Advanced Visual Studies (CAVS).[10] Very much in Piene's spirit, Haacke kicked off his exhibition with a parade of students shepherding *MIT Sky Line* (1967)—helium balloons linked to a single nylon cord—to be sent aloft between the shockingly new student center and Eero Saarinen's new auditorium and chapel. This choreography left the Beaux-Arts columns of old MIT behind, aiming for the new postwar "functionalist" architecture linked to technology and engineering.[11]

MIT Sky Line was ephemeral, and lasted only a few hours (as did its earlier prototype, a *Sky Line* Haacke staged in *Kinetic Environment 1 and 2* in New York's Central Park earlier in the year). But despite his obvious homage to Piene (whose work he "greatly admired" for the "human time patterns" unfolding in his motorized *Light Ballet*[12]), Haacke was signaling at MIT his departure from the Zeros' sometimes mystical gestures. In *Sky Line*, the balloons were seemingly just vehicles for launching a technical drawing into the sky. Play was now partnering with the abstraction of systems.

Systems pervaded MIT. Fed by MIT professor Claude Shannon's information theory and codified at the famous Macy Conferences in New York from 1946 to 1953, systems and cybernetics stretched from Jay W. Forrester's applications in social science to the major contributions of Norbert Wiener in mathematics and Vannevar Bush in computational

engineering. Wiener, a galvanic presence at MIT until 1964, published *Cybernetics* in 1948, with a revised second edition put out by MIT Press in 1961. It's safe to say that once Ludwig von Bertalanffy's *General System Theory* was published by the literature and art firm Braziller in 1968, the artworld had its bookend bibles for a systems revolution.[13] Andersen's invitation to Haacke confirmed the momentum, reinforced by Kepes's appointment of Burnham to CAVS shortly thereafter.

Jack Burnham was linked closely to both Haacke and Piene; when Kepes's first letter was sent to him in June 1967, its opening sentence—"I learned about your work from Otto Piene"—reveals a probable link to Haacke, who'd known Piene since the late 1950s, and Burnham since 1961.[14] Burnham in turn sent Kepes an essay he had published on Haacke's work a few months before as a supplement to the journal *Tri-Quarterly*, and offered to teach a course on the subject of "Systems and Art."[15] While at CAVS, Burnham included Haacke in more generic essays on "Systems Esthetics" in 1968 and "Real Time Systems" in '69, both published in *Artforum*. Deeply enthused about "systems," Burnham described Haacke's work in 1967 as a kind of "natural medicine" for humans beleaguered by rapid-fire industrialized capitalism. Commenting on Haacke's preference for simple technologies in mobilizing his systems, Burnham wrote:

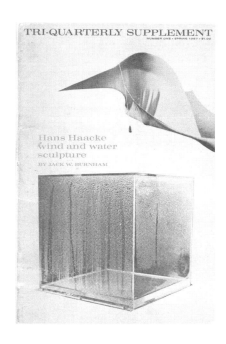

Jack W. Burnham's monograph on Haacke, spring 1967.

> Today in the engineering of complex systems the problem is to make the man-machine relationship as smoothly functional as possible. . . . For this reason—and for more practical ones—Haacke's devices are purposely kept simple and technically unelaborate. . . . [T]hey are fragile *systems* not stable *objects*.[16]

The necessarily new forms associated with "systems" were difficult to submit to aesthetic judgment. Unlike "kinetic art," under whose rubric Haacke had first come to MIT,[17] systems offered little in the way of "composition." (Haacke recalls that already by the late 1950s he had become "intrigued by non-compositional developments" in European and American art.[18]) Moreover, systems' interactivity was not a matter of knobs and buttons. "In some cases I was asked only to look," wrote Burnham in 1967 of his visit to Haacke's studio, "as a box would do its 'work' with no human intervention."[19] In the MIT student newspaper reviews of the 1967 show, the phrase "kinetic sculpture" yields explicitly to "systems." As *The Tech* reported:

> Haacke rejects the name "sculpture" for his works. He calls them "systems," noting that they "have been produced with the explicit intention of having their components physically communicate with each other, and the whole communicate physically with

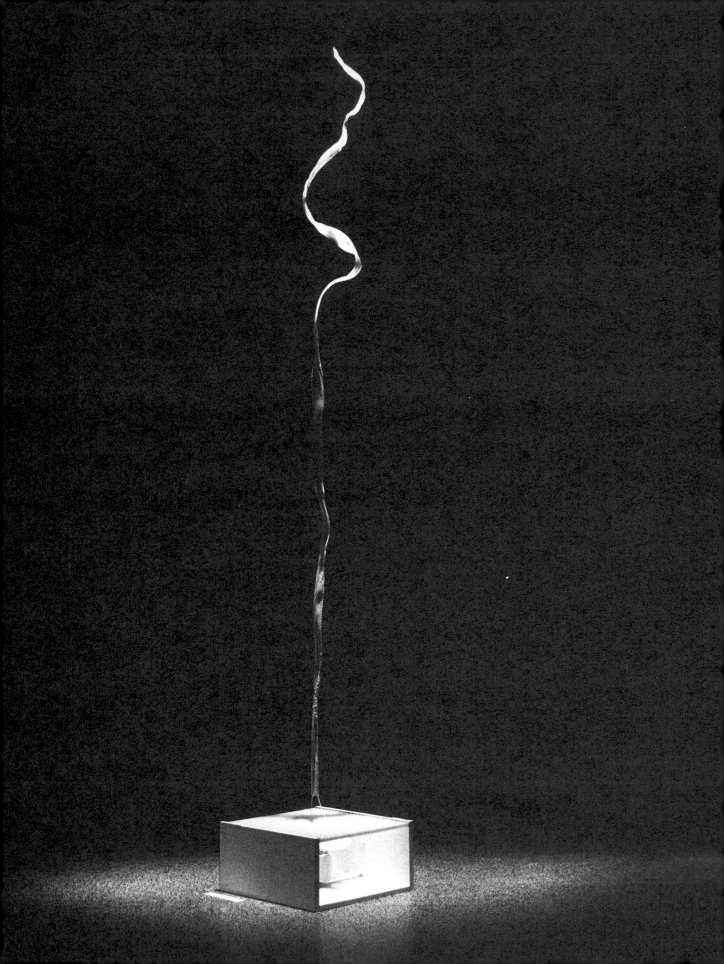

the environment. . . . Changes are desired and are part of the program—they are not due to the shifting experience of the viewer."[20]

Systems called to stranger discourses of feedback, recursive loops, automatic functions, and autopoesis. Most remarkably, even if they sometimes needed human agency to set them in motion, Haacke's systems in 1967 were positioned explicitly as being outside standard aesthetic discourses involving emotion, interpretation, culture, and memory. Haacke's earliest "systems" were in some measure outside the human altogether.

This is the paradox—that mere months before his turn to the social, Haacke was capable of arguing for a systems art that was wholly independent of the humans perceiving it. (Although the artist now quotes Lenin, "everything is connected to everything else," at the time his priority was to argue against the banality of "art appreciation."[21]) Rather than prosthetic "extensions of man" in the 1960s theories of Canadian English-professor-turned-media-guru Marshall McLuhan, Haacke's technologies anticipated the 1980s work of German literary-theorist-turned-media-guru Friedrich Kittler—less enhancements of a coherent human body than propulsions to the post-human.[22] Even Burnham, who had proposed to consider the artist's "natural medicine" in terms of a tradition of "organic rapport" with nature (à la Thoreau), was "shocked" at Haacke's abrupt response, when the artist wrote:

> I hate the nineteenth century idyllic nature loving act. I'm for what the large cities have to offer, the possibilities of technology and the urban mentality. Plexiglas, on the other hand, *is* artificial and strongly resists either tactile sensuality or the 'personal touch'. Plexiglas, mass-production—Thoreau—they don't really fit together.[23]

Haacke's rejections, as in Kittler's later attempt at "driving spirit [*Geist*] out of the humanities,"[24] may have been responses to Fascist appropriations of these very tropes (nature-loving, blood, soil, and spirit). Certainly the failure of the great German philosophical tradition either to prevent or comprehend the atrocities of World War II caused a crisis among all thinking Germans. There was also a generational disgust at the traditional discourses of "empathy" that still haunted art criticism. For whatever reason, by 1967 Haacke was reaching for a newly dispassionate art. As he recently recalled his position: "I rejected the traditional thinking of the romantic, and rejected the psychological, which exudes the magic of all art criticism."[25]

The canonical *Condensation Cube* (first conceived in 1963, and executed in 1965) reveals the barometric operation of the systems Haacke wanted to employ. The fact that a larger version was exhibited under the title *Weather Cube* at MIT in 1967 troubles some interpretations that place this work either with the 1960s cubic objects of Minimal Art (courting what Michael Fried called "objecthood"[26]), or along the path to full-blown institutional critique (as theorized by Benjamin H.D. Buchloh[27]). The current re-installation allows us to re-open the case of Haacke's most famous cube. Constructed of the synthetic glass substitute thermoplastic acrylic (poly[methyl 2-methylpropenoate], developed by a German

White Waving Line, 1967, in installation at MIT in 1967.

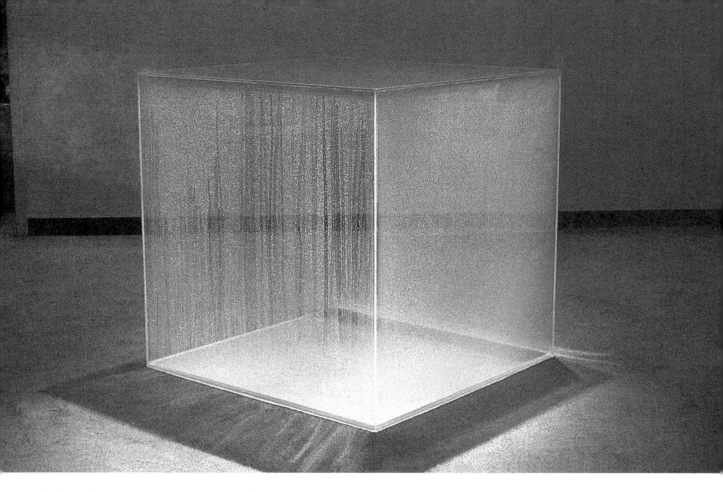

Condensation Cube (exhibited at MIT in 1967 as *Weather Cube*), large version, 1967.

chemist in the 1930s, researched during wartime for airplane windshields, and later marketed in the US under trade names such as Plexiglas, Lucite, or Perspex), the cube's flawless transparency extends to its chemically fused facets. A tiny hole drilled in a top corner allows the introduction of water to a depth of about an inch in the bottom of the box. Crucially, the box is less an object than a device for staging a slowly unfolding sequence of events. As in the cloud chambers made by Victorian physicists for mimetic experiments, the water in Haacke's *Weather Cube* forms a microclimate system.[28] Although Haacke now demurs that "weather" is no different from "condensation" ("they are the same thing"),[29] I would argue for their difference. Condensation is commonly experienced on the surfaces of a nearby object (at a Minimalist scale); *weather* happens atmospherically (at a systems scale). To model condensation is a modest aspiration; to model weather aims at the orders of the world.

In 1967 Burnham could already see how these "weather" boxes would connect with Haacke's wind devices, with global implications: "The Earth itself could be looked upon as a great wind making device forming patterns of evaporation, rain and humidity over its surface as a kind of enormous condensation container."[30] Unaware of anthropogenic climate change, Burnham shared Haacke's view of the *impersonality* of "weather" in 1967, whereas the reinstallation of Haacke's systems in 2011 may prompt reflections on collective responsibility.

Accepting its familiar title, *Condensation Cube*, is to tame this broader set of implications, as water circulates through several of its available states: beginning as liquid, evaporating into mist, and slowly condensing again into liquid droplets that form orderly yet subtly random patterns that run down the sides as rain.

Even within the heady context of systems art that first enveloped it at MIT, the self-sufficiency of this system can be called into question. Around which inputs and outputs is the system defined? What is black-boxed, and what interrogated as functional? Most importantly for my argument here, what are its boundaries—*Does the system include us? The artworld? The larger climate?* For Haacke in 1967, just beginning to explore extremely diffuse systems of animal and environmental life, the boundaries of the system in question still excluded the human. The miniature model, and the closed universe it implied, called up the magic of autonomous art:

> . . . in spite of all my environmental and monumental thinking, I am still fascinated by the nearly magic, self-contained quality of objects. My water levels, waves and condensation boxes are unthinkable without this physical separation from their surroundings.[31]

Details reveal the artist's efforts to maintain that "physical separation." The distilled water introduced into the various Plexi structures must be treated with copper sulfate to prevent unwanted biotic "systems" from blooming. Similarly, the tiny hole drilled at the top must be managed to prevent humidity from escaping—covered either by clear tape or a set screw in order for the condensation "system" to continue to function. Art history's canonization of *Weather Cube* as *Condensation Cube* is largely unreflective about these aspects of the work, sometimes reducing the work to an object, or at best celebrating it as the container of processes "completely independent of the viewer's perception" (as Buchloh correctly relays Haacke's intentions).[32]

In complicating these received views (and in the spirit of systems theorizing), I suggest that what we call *Condensation Cube* would be unlikely to display its internal weather theater without two inputs from outside the box. First, there must be light shining into the interior (as Haacke himself admitted)—light that cannot then escape, becoming heat (the "greenhouse effect") and causing the water to evaporate into the air trapped inside the box. Second, the box's exterior must become cooler than this interior, whether as a result of air conditioning or the natural cooling of its surrounding after sunset. It is only this differential of a cooler exterior that propels condensation to occur, but only after the differential of a hotter interior has allowed evaporation to precede it. It is no accident that the piece exhibited at MIT as "Weather Cube" entered art history as "Condensation Cube"—reinforcing the smaller scale of an object that could be moved about.

Large Water Level, 1964.

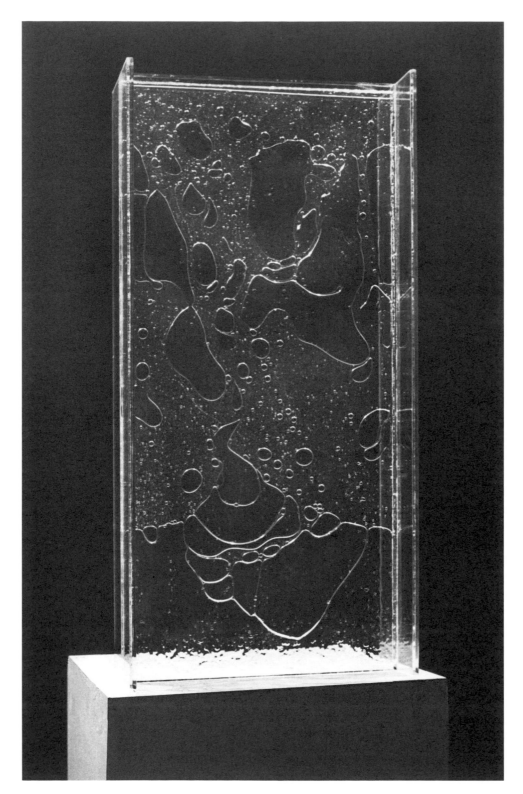

Clear Flow, 1966.

The tension between environmental versus object implications is even more problematic with other works, lost since 1967 but now refabricated. The title of *Double-Decker Rain* (1963) for example, implies that the decks "contain" the rain as an isolated or self-generated system, an impression furthered by the few reproductions in major Haacke monographs.[33] The documentation of *Clear Flow* (1966) conveys the same autopoesis, the patterns of its bubbles seemingly self-generated. Only the process of reconstruction brought out that the photographs capture an evanescent moment in these systems, when the fluids in the box are struggling to return to homeostasis. Indeed, this and other works *depend* on being agitated by human hands, which are required to begin the process by turning the box upside down like an hourglass.

This introduces the crucial component of participation, which interested Haacke deeply at the time (see his first published statement from 1965 reprinted herein: "make something which the 'spectator' handles, with which he plays, and thus animates.") Clearly intending to question the passivity of vision (note the scare quotes around "spectator"), Haacke produced hand-manipulated Plexi-and-water pieces even before making the self-contained *Condensation Cube*—as, for example, with *Rain Tower* as early as 1962 (see p. 31). He often photographed visitors peering at these works (presumably after agitating them), and believed such interactions would transform them in important ways.[34] It is this paradox I want to emphasize—how Haacke struggled to keep the human from impeding the autonomy of these fluid systems, yet recognized the importance of the art in restoring humans' own equilibrium (via empathetic "systems" he was not acknowledging as part of his concern). Notably, particularly in the early published photographs, we are rarely shown the visitor actually holding, turning, pushing, or handling a piece (a decorum broken by Eric Pollitzer in his 1965 photograph of the artist himself moving *Wave,* for which see p. 17.) Even when discussing his contribution to a conceptual art show in which he put a gallery humidity detector on display, Haacke insisted there was no input from the human—although it is precisely the sweat, heat, and vaporous breath of crowds that the device is ordinarily used to monitor.[35]

The human could watch; the human might even push a system into motion, but the system's unfolding was *independent of the human* in 1967. Such autonomy, ideally, would exclude even the machine: "I would want all the machines to disappear and for the sails or balloons or whatever to become completely autonomous."[36] How can we understand the artist's resolute desire to circumscribe the human or the machinic from the system, when cybernetics itself originated in an application of mechanical feedback theories to psychological human processes? Was Haacke alone in reading systems art as black-boxed from the human, at least before 1968?

SYSTEMS' GENEALOGY

At MIT, the yearning for systems goes back to its nineteenth-century origins, when architect William R. Ware and Institute President William Barton Rogers drew on the *beaux arts* (as taught in Europe) but instituted *techne*—the art of crafting, of making, of innovating and engineering. As Ware put it in his outline for the program in 1865:

The trouble is technological; *there is a want of system and method*, and of means for general collection, and a general diffusion of their results.[37] [emphasis added]

That anxious "want of system and method," and the view of technology as its solution, would continue with the Institute's placement of Kepes at CAVS and Haacke at the Hayden.[38] Haacke's show thus played to a much longer obsession, but it was important that it took place at the hinge of the late sixties—an epoch later described by Burnham as the "great hiatus between standard modernism and postmodernism."[39] "Systems" might initially have promised Burnham a kind of "natural medicine" inoculating art lovers against industrial alienation, but Haacke's show of luminous, autopoetic works unfolded in 1967 amid a burgeoning military-industrial complex—just months before students' principled attack on that much larger "system" forced MIT to implement massive change.[40] Having been introduced to systems thinking by Burnham, Haacke had read Bertalanffy and Weiner and was familiar with the theory's imbrication in protocols of military command, control, and communication. Only later would this attribute of systems render the label of "Systems Art" unappealing.[41]

Since Haacke's Systems Art initially posited that the human subject was only an instigator or perceiver of a system that excluded her, we are confronted with a curious logic—that the very extension of systems and cybernetic theory into the human sciences coincided with Haacke's *removal* of humanist traditions via Systems Art. Of course, eliminating human error (which "empathy" could be seen to be!) had always been the very point of systems. As Burnham would later summarize its force: "Ultimately . . . systems theory may be another attempt by science to resist the emotional pain and ambiguity that remain an unavoidable aspect of life."[42] If resisting sentimentality, romanticism, empathy, and "the 'personal touch'" meant turning to systems, did it also mean rejecting the environmental politics of Thoreau? Haacke's systems in 1967 oscillated between "natural medicine" and an edgy aesthetic of technological and urban orders.

The very ambiguity of Haacke's early Systems Art—concern for nature's operations combined with a critique of traditional humanism—are both available in the genealogy of systems theory. But by making systems into *art*, Haacke began to confront those theories' very instrumentalizing logic. It may even be that the installation of these pieces at MIT brought such ambiguities to a head for Haacke, clarifying how the necessarily social component of "art" systems precisely allows art to do more than foment further systematization. Certainly his growing understanding of "systems" as a component of US military practices increasingly gave the artist pause, especially after 1970. Indeed, a few months after MIT he would ruminate that "An artist is not an isolated system."[43] This was given force in 1969, when he helped found the Art Workers Coalition in January and included in his show at Howard Wise Gallery the first poll of a gallery's viewers: a residence and birthplace inquiry that "invited them to create a self portrait and look at themselves in a (sociological) mirror."[44]

The confrontation between systems and the social is attested by Haacke's archive of unpublished early photographs, which frequently show families engaging the works in

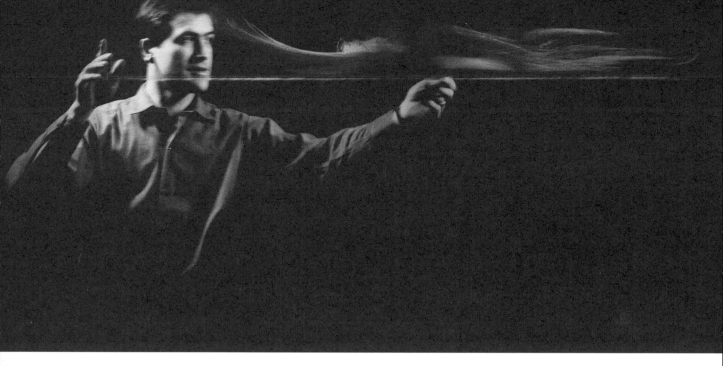

Hans Haacke with *Wave* (1965), photograph by Eric Pollitzer (courtesy of Archives of American Art, Smithsonian Institution, Rudi Blesh papers).

the 1967 installation. And almost all of MIT's student newspaper articles show visitors enjoying works that were elsewhere described as autonomously boxed. The "magic" of objects that Haacke still craved remained inert without humans setting some of these systems in motion. And although the artist was extricating himself *via systems* from his past with the ZEROS, the kickoff for the MIT show was clearly linked to their Happening-type events. Scores of student helpers were marshaled for filling, tying, and tethering the balloons of *MIT Sky Line* (p. 8), and for the different experiments with weather balloons in the great dome of MIT's main entrance. Here Haacke planned to suspend an enormous sphere (partially inflated with helium), forty feet wide, in the center of the dome. Like a massive version of the *Sphere in Oblique Air Jet* (1964) on view in the gallery, the balloon was supposed to float mysteriously over a giant fan in a classical demonstration of the Bernoulli principle. But despite advice from MIT meteorologist Erik Møllo-Christensen, the sphere drifted, developed a leak, and had to be removed.[45] Well after the show's opening, Andersen got four smaller weather balloons to float on airshafts from fans housed in the four corners of the dome lobby (see *The Tech* photograph p. 21). Such "weather" was messily mechanical, and exuberantly social.

Grass also revealed the social parameters of systems edging their way into Haacke's 1967 procedures. Known to art history as *Grass Grows* (and previously dated to Cornell's *Earth Art* show in 1969 for its first articulation),[46] this work originated at MIT as *Grass,* a

"system" rather than a "work" of earth. As a system, the pile was intended to demonstrate phenomena over time: "Haacke exhibit features systems of 'grass,' 'ice'").[47] Historically excavating its full system means that the 1967 *Grass* would have to include dubious students shoveling dirt into a pile, commercial manufacturers selling winter rye seeds, and even more dubious maintenance workers watering and tending the crop planted in the heap. (According to Andersen, the janitorial staff ultimately "adopted" *Grass* and fought to defend it from students' "hacks."[48]) These social components of the systems on view proved difficult to control. *The Tech* reported that *Ice Stick* was marked by "the effects of many warm hands," and noted "*Grass* has taken a heavy beating and is pockmarked with footprints." But the larger social systems around these works could both outline the parameters of art and celebrate Haacke for enlarging them, as in the quip reported from administrator Marietta Millet: "These people who walk on sculpture—really!"[49]

The humor in Millet's response stems precisely from the exhilarating freedom Haacke's systems produced *for art*, with change welcomed by the artist who "deliberately designs his 'systems' to evolve in time and be affected by time."[50] The student writers learn in print, over the passage of several articles, and eventually come to question the entire "philosophy of art."[51] Revealing his new interest in sociology, Haacke responds cautiously to their questions: he "would have to define art" in order to classify these works as such; but "the display

Top: Child eyeing *Large Water Level* (1964–65) in MIT's Hayden Gallery, 1967.

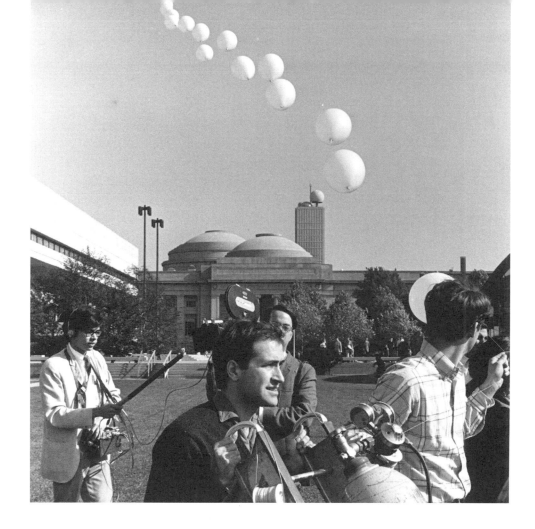

of his work does qualify as an 'exhibit' due to the fact that it is being held in Hayden." (It is the institutional circumstances, not its status as "art," that produce the works as an "exhibit.") The final query as to whether his systems really have "artistic significance" yields Haacke's most telling response: "'It all depends on the people (who view the work),' he said."[52]

EPHEMERAL SYSTEMS

After a year in Philadelphia (1961–62, when he met Burnham) and another in New York (1962–63), Haacke abandoned painting and print-making for much less conventional media. Photographs Haacke took of his studio in Cologne (in 1964 and 1965) already show this freedom—in experiments edging onto win-dowsills, on spots of outdoor ground, or even

Top: Haacke wheeling helium tank with MIT students assembling *MIT Sky Line*, October 24, 1967 (photograph courtesy of MIT Museum).

Right: Visitor to Howard Wise Gallery in 1966 manipulating Haacke's *Column of Two Clear Liquids*.

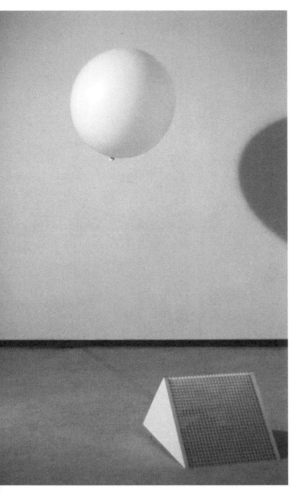

Sphere in Oblique Air Jet, 1964–67.

extruding as soapy foam from columnar machines—an exploration of water he later abandoned.[53] Proposals for "ZERO on Sea" in August 1965 included the mass of seagulls that he would not have occasion to produce until *Live Airborne System* three years later.[54] (For images of these and other ephemeral projects, see pp. 55–70.) Moving back to New York in the fall of 1965, the artist began to question the very categories of "sculpture" and "kinetics." The roof of his Bowery studio became a laboratory for Systems Art.

Confessing to Burnham that he liked the separation and autonomy of art, but also longed for "something unconfined, like the ocean, the desert, Grand Canyon, or even . . . interstellar proportions," Haacke utilized the "free" urban space of his rooftop as a corner of the cosmos.[55] *Water in Wind* from 1968 is photographed from high, low, and in color, to capture a rainbow forming in the prism of droplets in Haacke's spray.[56] Casting ice, and photographing it "freezing and melting" in 1969, he also piled chunks of urban snow into an impressive rooftop mound as dusk fell in the city. He explored the liquid state of water by photographing its trickles from a perforated hose in the 1969 *Cycle;* again, the "urban mentality" frames the set up (which would be repeated in *Tokyo Trickle,* and *Trickle, Maenz Gallery,* 1970 and 1971, respectively). Site began to play a role, and geometry to waver—in 1970, *Bowery Seeds* replaced the monoculture of MIT's *Grass* with something airborne and weedier; *Spray of Ithaca Falls . . .* in 1969 was austere compared to the chaotic urban garden he produced in Boston with water hoses and spray nozzles in *Fog, Dripping, Freezing* in '71.

Their full titles suggest the discourses about site specificity and process that were entering Haacke's systems after MIT—*Spray of Ithaca Falls: Freezing and Melting on Rope February 6, 7, 8 . . . , 1969*. What he has jokingly referred to as his "Franciscan" phase expanded from seagulls to a repertoire of animals: *Ant Co-op* and *Chickens Hatching* from 1969, *Ten Turtles Set Free* from 1970. Near the Fondation Maeght in Saint-Paul de Vence in southern France, the artist focused on different systems in a single set up in the woods, *Transplanted Moss Supported in Artificial Climate* in one view becomes *Artificial Rain* in another. There is nothing particularly "systematic" about these ephemeral, process-oriented explorations. The close-up view from the Rhine's bank in Krefeld (then in West Germany; 1972) and the *Monument to Beach Pollution* in Carboneras, Spain (1970), are dissimilar in scale, framing, and proportion—but they share a focus on the "systems"

depositing trash and pollution by water. Significantly, these are systems of pollution produced *by people.* Crucially, by the time of the 1972 Krefeld exhibition, Haacke was willing to merge documentation with action—the *Rhine Water Purification Plant* transformed the Plexi containers of autopoetic "weather" into housings for filtration systems that at once "represented" the discharge from the Krefeld sewage plant, and actively intervened to reduce it.[57]

This full-blown recognition of the "social" in systems was fueled by Haacke's own increasing political concerns, and by the politicization of his work following the cancellation of his Guggenheim museum show in 1971.[58] The now (in)famous tipping point, *Shapolsky et al., Manhattan Real Estate Holdings, a Real-Time Social System, as of May 1, 1971,* is a breathtakingly different kind of "system," social to the core. But the explicit politics of this work (which Haacke was also living, as a cofounder of the Art Workers Coalition and an advocate for artists' work/live and resale rights) has eclipsed the ephemeral process-oriented systems he was still producing after *Grass* at MIT—the beginnings of *Guggenheim Beans* (later realized as *Directed Growth* in Krefeld) and *Guggenheim Rye in the Tropics,* both "unfinished" but documented in the museum's sculpted Frank Lloyd Wright interiors. Yes, it could be claimed that these dirt-based systems, brought into the alimentary but still white and antiseptic galleries of the Guggenheim, "reveal" an institutional critique—but I have struggled to explore the internal boundaries that Haacke's "systems aesthetic" originally entailed.

An ephemeral work described by one curator as "essentially parodic" reveals these boundaries precisely—*Norbert: "All Systems Go"* from 1970–71.[59] Named for Norbert Wiener yet referring to systems rather than cybernetics, the work featured a pet mynah bird which Haacke was attempting to train to say "All systems go" (the signal for blast-off readiness in the space age) in time for the Guggenheim opening. As Luke Skrebowski, a sympathetic scholar of this piece, has imagined it:

> A white cube. A black bird with bright yellow stripes around the eyes sits in a chrome cage. It rocks gently on its perch. Silence. Occasional scrabbling sounds [. . .] Time passes. Nothing happens. Suddenly, the caged bird speaks. "All systems go" it squawks. And again, "All systems go." A pause. "All systems go. All systems go." Repetition to inanition. "All systems go."[60]

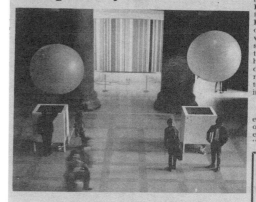

MIT student newspaper, *The Tech*, documenting the successful launch of a revised balloon project by Haacke in MIT's main lobby, November 4, 1967.

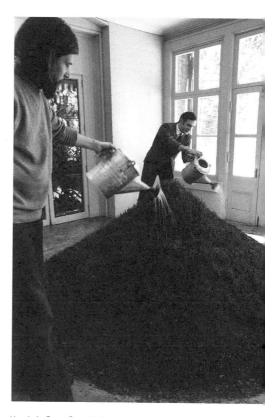

Haacke's *Grass Grows* being watered at the *Earth Art* exhibition by its curator Willoughby Sharp and museum director Tom Leavitt, Cornell University, 1969 (photograph by Sol Goldberg for Cornell University).

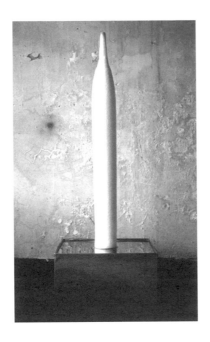

Ice Stick, 1966.

View of Haacke's studio in Cologne, 1965.

Skrebowski argues that "[the 1969] *Chickens Hatching* makes direct use of the possibilities presented by cybernetic systems [while the later] *Norbert* . . . seems to negate them."[61] As Skrebowski argues: "[in *Norbert*] cybernetic theory . . . is mocked, its optimistic feedback-steered vision of human progress undermined . . . [in] the sardonic refrain of a trained mynah bird."[62] This reading aligns with Buchloh's view of systems work as inherently critical, but I want *Norbert* to foreground a different problematic. What is the boundary that defines the "system," outside of which are set up the terms for its critique?

The boundary that Haacke consistently vexes is the boundary he continually redraws: the elite container of artworld signification *must* be conceived as a separate system from the real world— a world in which Haacke buys the mynah bird, sets up a feedback loop (quite literally) in which he endlessly plays a tape of the intended utterance and waits to reward the bird if it should ever say it, until such time as the system (as I am seeing

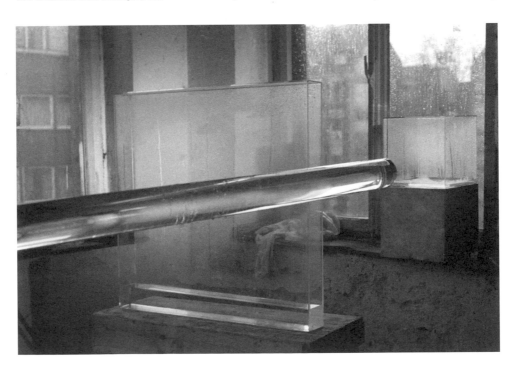

it, with much larger boundaries than Haacke finds useful) can be presumed to be homeostatic, with the bird named Norbert primed to utter "All systems go" for the now symbolic reward system of the artworld itself, transferred from the artist's hand to the bird's beak to the viewer's ear. The fact that this particular mynah bird proved "dumb" and the Guggenheim canceled the exhibition does not change Haacke's core requirements: the artworld would be the one system whose boundaries would have to remain intact, to contain the changing contents of other systems—whether the abstract droplets in *Condensation Cube* or the riotous patterns of colored papers—color-coded according to status as fully paying visitor, member, student, etc.—"ballots" in the *MoMA Visitors' Poll* (from the 1970 *Information* show: ballots inserted, I note, from outside the box, p. 25).[63] Haacke continued to think of these as systems, but they were now permeable to the social—and the artworld would never quite be the same.[64]

Earlier processes seen to "evolve without the viewer's empathy" at MIT could hardly jibe with a new reality in which the personal had become political. The constant was Haacke's conviction, set down on paper as he was preparing the MIT exhibition in 1967: "A system is not imagined, it is real."[65] *Hans Haacke 1967* will make a different *real* from the systems of air, ice, and water on view; we are more likely to think about the hydrocarbons burning at a distant site to fuel *Ice Stick*, the global climate implied by *Condensation (aka "Weather") Cube*, or the absurd inefficiencies of *Artificial Rain* and *Transplanted Moss*. Clearly, the ephemeral works' titles were already shifting to emphasize the human agency behind "artificial" climates and "transplanted" biota; the full social turn was not far behind. If we can no longer sustain the earliest belief that the systems of Systems Art are "absolutely independent" of humans, we can still take up Haacke's initial offer of an artworld space, time, and provocation to contemplate their unfolding.

NOTES

1. As, for example, curator Helen Molesworth and artist Allan Kaprow's "reinvention" of *Yard* (1961/2009) at the Hauser & Wirth Gallery in New York, and the refabrication of Haacke's own *Wide White Flow* in 2006, exhibited in his solo exhibition *Hans Haacke—wirklich—Werke 1959–2006* at Deichtorhallen, Hamburg, 2006, and in 2008 at the Paula Cooper Gallery, discussed below. (Repairs and reconstructions are made as required for each exhibition.)

2. Bill Arning, public discussion before the opening of *Stan VanDerBeek: The Culture Intercom* at MIT's List Visual Art Center, February 3, 2011.

3. For help with archives at MIT, staff members Alise Upitis and Laura Knott were indispensable; as were the staff at the Archives of American Art, Smithsonian Institution, in Washington, DC, and at Haacke's present gallery, Paula Cooper. The final element in the project's germination was intellectual—funded by the MIT 150th anniversary, we organized a forum for thinking about systems in the present and questioning systems in the past. Here I want to thank David Mindell, Leila Kinney, Tod Machover, and all the brilliant colleagues and facilitators who made possible the symposium "Systems, Process, Art, and the Social" on February 4, 2011, at MIT, with presentations by Ben Aranda, Michelle Kuo, João Ribas, Matthew Ritchie, and Matt Wisnioski.

4. The exhibition from October 1967 is referenced in *The Tech*, the MIT student newspaper, simply as a one-man show of Hans Haacke works. Curator Wayne Andersen identified the show as "Hans Haacke Wind and Water Works" in his curriculum vitae from 1969. Andersen file, Committee for the Arts Records, MIT Museum. This title is close to "Hans Haacke: Wind and Water," the one-person show that Haacke staged in 1966 at his New York gallery, Howard Wise, suggesting that at some point Andersen merely thought he was getting that exhibition. (He did not.) The poster designed for the exhibition by Jackie Casey reads simply: "Hans Haacke / Hayden Gallery / MIT."

5. "We are eager to make the Drawing (for want of a more complete word) a strong and integral part of the school." William Wurster to Gyorgy Kepes in Wellfleet, MA, August 1945, Gyorgy Kepes papers, Archives of American Art,

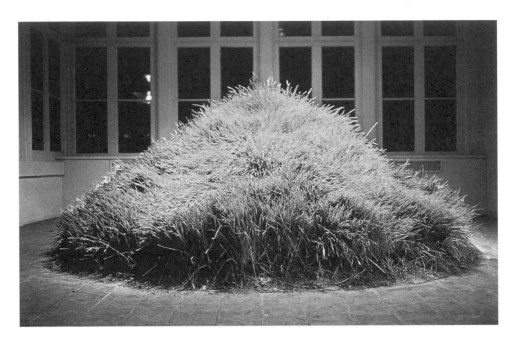

Grass Grows (first installed at MIT in 1967 as *Grass*), shown here in 1969 conical version.

Smithsonian Institution, reel 5303 fr 0175, as cited by Elizabeth Finch in her path-breaking "Languages of Vision: Gyorgy Kepes and the 'New Landscape' of Art and Science," Ph.D. diss., City University of New York, 2005. See my contribution to Arindam Dutta, ed., *A Second Modernism: MIT, Architecture, and the "Techno-Social" Moment* (forthcoming).

6. MIT's most notable contributions came with the development of radar in the "Rad Lab" (Radiation Laboratory), as detailed in Peter Galison, *Image and Logic: A Material Culture of Microphysics* (Chicago: University of Chicago Press, 1997).

7. See Reinhold Martin, *The Organizational Complex: Architecture, Media, and Corporate Space* (Cambridge, MA: MIT Press, 2003); and Dutta, *A Second Modernism*.

8. As summarized by Mark Wigley, "Prosthetic Theory: Disciplining of Architecture," *Assemblage* 15 (August 1991): 14. Founder of the MIT School of Architecture, William R. Ware positioned "the history of architecture, the theory of architectural ornamentation, the laws of proportion, of harmony and of geometrical and naturalist decoration" as humanist fine arts, while placing "mechanic arts employed in building, supervising, specifications, contracts, lighting, ventilation, heating, etc." on the scientific side of architecture. William R. Ware, letter to John Runkle (secretary of the Massachusetts Institute of Technology), April 27, 1865, 2, as cited by Wigley, "Prosthetic Theory," 26 n35.

9. Crucial to Haacke's development (and open for deeper historicization than can be accomplished here), the Zero Group was founded in West Germany in the late 1950s and at its zenith collaborated with groups in the Netherlands, Paris, Italy, Eastern Europe, and even Japan. The current summary of its history can be found on the Zero foundation website, http://www.zerofoundation.de (accessed June 2011): "In 1958, at their studio at Gladbacher Strasse in Düsseldorf, Heinz Mack and Otto Piene founded Zero. In 1961, Günther Uecker joined the group; and in 1966, Zero disbanded."

10. The history of "Systems Art" is only beginning to be written, but by all accounts Jack Burnham can be considered its founding theorist. For recent forays into this history, see Edward A. Shanken, "From Cybernetics to Telematics: The Art, Pedagogy, and Theory of Roy Ascott," in Roy Ascott, *Telematic Embrace: Visionary Theories of Art, Technology, and Consciousness,* edited and with an essay by Edward A. Shanken (Berkeley and Los Angeles: University of California Press, 2003); Luke Skrebowski, "All Systems Go: Recovering Jack Burnham's 'Systems Aesthetics,'" *Tate Papers,* no. 5 (Spring 2006), http://www.tate.org.uk/research/tateresearch/tatepapers/06spring/skrebowski.htm (accessed June 2010); and emerging research by Melissa Ragain, "Homeostasis is not enough: Order and Survival in Early Ecological Art," unpublished manuscript, courtesy of the author.

11. As Wayne Andersen recalls it, the wind swept the balloons dangerously close to traffic on Massachusetts Avenue, and he and Haacke decided to authorize the immediate untethering of the balloons. Andersen, interview with the author, July 13, 2009, Boston.

12. Hans Haacke, interviewed by Jack W. Burnham, in his "Hans Haacke Wind and Water Sculpture," *Tri-Quarterly Supplement* 1 (Spring 1967), 19.

13. Norbert Wiener, *Cybernetics: Or, Control and Communication in the Animal and the Machine*, 2d ed. (New York: MIT

Press, 1961); and Ludwig von Bertalanffy, *General System Theory: Foundations, Development, Applications* (New York: Braziller, 1968).

14. Kepes, letter to Burnham, June 5, 1967, Burnham file, Center for Advanced Visual Studies (CAVS), MIT. In an interview with the author on March 26, 2009, New York City, Haacke recalled (typescript 12): "I met him [Burnham, in 1961–62] when I was in Philadelphia. He was a junior faculty in some Delaware college. And somehow, I don't remember how, I met a graduate student at the University [of Pennsylvania], who's still around, by the name of Jimmy Harithas I don't know how he had heard, or knew. Well, he had a car, I didn't have a car. We made a trip down to this college and met Jack Burnham. And since then we were in touch." Burnham introduced Haacke to the concepts of systems theory in the work of Wiener and von Bertalanffy, and confirmed Haacke's notion of Duchampian "ready mades" as capable of describing this systems work.

15. Burnham, letter to Kepes, November 17, 1967, Burnham file, CAVS archives, MIT. Never taught at MIT, the intriguing course on "systems and art" had been developed with an engineer when Burnham was at Northwestern; Burnham's systems morphed into structuralism and the material was eventually published as *The Structure of Art* (New York: Braziller, 1971). As Burnham described "systems methodology" to Kepes: "It is a radical departure from the usual sticks and screen design class, but that is what it meant to be. Since the writing of this paper there have been a number of changes and improvements in the course." I have identified a loose mimeographed typescript in the Burnham file in the CAVS archives as the course proposal. It is annotated in Burnham's handwriting, "for G. Kepes," and titled "Some thoughts on systems methodology applied to art"; based on the correspondence it can be dated November 1967 and is cited henceforth as "Burnham, 'Systems methodology' 1967." In the correspondence, Burnham also promised to send Kepes the monograph he had recently written on Hans Haacke ("Hans Haacke Wind and Water Sculpture" in the *Tri-Quarterly Supplement*).

16. Burnham, "Hans Haacke Wind and Water Sculpture," 10–11.

17. *Miscellaneous Motions of Kinetic Sculpture* (April 4–May 2, 1967) included more works by Haacke than any other artist: *Large Wave* (1965), *Floating Sphere* (1964–66), *Condensation Wall* (1967), and *White Sail* (1965–67). Other artists in the show were Len Lye, Gerald Oster, Earl Reiback, Vassilakis Takis, Günther Uecker, and Jean-Pierre Yvaral.

18. Haacke interview, March 26, 2009 (ts 9).

19. Burnham, "Hans Haacke Wind and Water Sculpture," 3.

20. Peter Mechsler, "Haacke to Exhibit Kinetic Art," *The Tech*, October 17, 1967, 5. After this article, reporting on Haacke's gentle corrections, the phrase "kinetic art" was not used again.

21. Hans Haacke, email communication with the author, August 31, 2011.

22. Kittler's best-known work in English is the 1999 translation (by Geoffrey Winthrop-Young and Michael Wutz) of his 1986 study *Gramophone, Film, Typewriter* (Stanford University Press); McLuhan's comparable treatise is the 1964 *Understanding Media: The Extensions of Man*, reissued by MIT Press in 1994.

23. Haacke to Burnham, letter sent prior to April 1967, as quoted by Burnham in "Hans Haacke Wind and Water Sculpture," 13. Although Haacke begins with an ameliorating "Good old Thoreau" and acknowledges "there's some [romanticism] in me," his rejection of Burnham's transcendentalism is complete.

24. Friedrich Kittler, ed., *Austreibung des Geistes aus den Geisteswissenschaften: Programme des Poststrukturalismus* (Paderborn, Munich, Vienna, Zürich: Schšningh, 1980).

25. Haacke interview, March 26, 2009 (ts 18).

26. Michael Fried, "Art and Objecthood" (1967), anthologized in his *Art and Objecthood* (Chicago: University of Chicago Press, 1998), 148–72.

27. Benjamin H.D. Buchloh, "Hans Haacke: Memory and Instrumental Reason" (1988), as anthologized in Buchloh, *Neo-Avantgarde and Culture Industry: Essays on European and American Art from 1955 to 1975* (Cambridge, MA: MIT Press, 2000), 202–41.

28. On the experimental cloud chamber and mimetic experiments, see Galison, *Image and Logic*. On the connection of Haacke's *Condensation Cube* to contemporaneous climate-control systems in architecture, see Mark Jarzombek, "Haacke's Condensation Cube: The Machine in the Box and the Travails of Architecture," *Thresholds* 30 (Summer 2005): 99–103.

29. Discussion with the author, May 24, 2011, New York.

30. Burnham, "Hans Haacke Wind and Water Sculpture," 11.

31. Haacke, letter to Burnham, written before April 1967, as cited in Burnham, "Hans Haacke Wind and Water Sculpture," 14.

32. Buchloh, "Hans Haacke," 218. Buchloch's thoughtful piece on Haacke has certainly been the most influential since the writings of Jack Burnham and Edward Fry in the late 1960s.

33. This reading is not Haacke's, since his thought was to capture the visual similarity with rain rather than its containment. Haacke, email, August 31, 2011.

34. As he acknowledged in the interview Burnham published in 1967, Haacke felt that the slower rhythm of his systems work was healing for the participant: "It is more related to what human beings have known in terms of natural motion. I watched many people during my exhibitions. I was surprised and happy to see them loosening up after handling some of my objects." Burnham, "Hans Haacke Wind and Water Sculpture," 19.

35. In our March 26, 2009, interview (ts 13), Haacke stated that the hygrothermograph piece was intended for a conceptual art show as an ironic commentary on the institution, not as an actual measure of the human / HVAC systems interacting in the galleries:
CAJ, "By '69 you're looking at hygrothermographs in an art gallery so you know that when bodies come into the gallery, the temperature rises."
HH, "No, that was not the idea behind it. I would suspect that the visitors, unless it's really packed, have no effect on the humidity."

36. Haacke, interviewed by Burnham, "Hans Haacke Wind and Water Sculpture," 20.

37. William R. Ware, *An Outline of a Course of Architectural Instruction* (Boston: John Wilson and Sons, 1866), 9, cited in Wigley, "Prosthetic Theory," 13.

38. These fears continued through to the founding of the Media Lab, where ameliorative Kepes/Piene models were contested by former CAVS fellow Nicholas Negroponte, who hoped to achieve "something closer to the cockpit of an F14 than a barn." Memorandum to Ricky Leacock and Otto Piene from Negroponte of the Architecture Machine Group, dated December 9, 1977, CAVS archives, MIT. Thanks to the scholarship of Meg Rotzel at MIT for revealing this fascinating contest. The fact that Burnham included Negroponte in his *Software* exhibition at the Jewish Museum, New York, in 1970, and even put his work on the catalogue's cover, suggests the convergence of these interests at the time.

39. Jack Burnham, personal correspondence with Edward Shanken, April 23, 1998, as cited in Shanken, "The House That Jack Built: Jack Burnham's Concept of 'Software' as a Metaphor for Art," *Leonardo Electronic Almanac* 6:10 (November 1998): unpaginated n3, now hosted at http://www.artexetra.com/House.html (accessed June 2011).

40. Notably, the reviews of Haacke are on pages of the student newspaper that also contain recruitment ads for Grumman, Hughes Aircraft, and the like. Student protests against the militarization of MIT attempted to shut down various functions of the university in 1968, when MIT's Instrumentation Laboratory was receiving over $50 million from the Department of Defense and NASA. By 1969, the funding of the Instrument Laboratory constituted *one-quarter* of MIT's total operating budget. See Finch, "Languages of Vision," 276–77. MIT's President Howard W. Johnson (in office from 1966–71) gained praise for his handling of the situation, advocating for the divestment of the Instrumentation Lab in 1970, plus a relocation and partial restructuring of the Lincoln Labs.

41. Indeed, Haacke's decision not to use "Systems Art" in the title for the accompanying gallery of ephemeral documentation here in 2011 can be seen as part of his post-1967 education, which revealed to him just how involved with military operations "systems" had become. I propose that prior to the MIT show, systems was an interest of Haacke's but not an "aesthetic." The impetus of the MIT exhibition seems to have prompted numerous statements (see those reprinted in this book), as well as discussions with *Tech* newspaper writers, in which Haacke explicitly shifted from "kinetic" to "systems" in his discourse. From this point in the essay, therefore, I capitalize "Systems Art" to convey this moment of canonization for both Haacke and Burnham.

42. Jack Burnham, "Introduction," *Great Western Salt Works: Essays on the Meaning of Post-Formalist Art* (New York: Braziller, 1974), 11.

43. Haacke, "from a talk . . . at the annual meeting of the Intersocietal Color Council, April 1968," as cited by Burnham, "Real-Time Systems," in *Great Western Salt Works*, 30.

44. Haacke, email, August 31, 2011. In an interesting way, this "mirroring" returned to concerns that pre-dated the systems work, evident in constructions that Haacke made using highly reflective mirror foil on wooden forms, while still in Cologne.

The Art Workers' Coalition began when Haacke and others organized to support the protest by kinetic artist Takis, who had physically withdrawn his work on January 9, 1969, from the 1968 MoMA show *The Machine at the End of the Mechanical Age* in resonance with *Mai '68* in Paris and in outrage at the continuing war in Vietnam. The coalition disbanded by 1971, but its legacy was revived by activist collectives in the 1980s such as Artists Meeting for Cultural Change, Group Material, Guerrilla Girls, the Women's Action Coalition, Act Up, and others.

45. Referenced as "Eric" in a letter from the Director of Exhibitions sent to Haacke in October 1967 (Haacke personal archives), but correctly spelled "Erik" in Bobbi Lev, "Balloon Problems Mar Haacke Opening," *The Tech*, 27 October 1967, 1.

46. *Grass Grows* was Haacke's well-documented submission to the 1969 *Earth Art* show curated by Willoughby Sharp for Thomas Leavitt at the White Art Museum (and outside it!) at Cornell University, Ithaca, New York. Haacke's *Spray of Ithaca Falls: Freezing and Melting on Rope, February 7, 8, 9 . . . , 1969* was part of the same exhibition, which included Robert Smithson and Dennis Oppenheim, enthusiastically assisted by a young architecture student, Gordon Matta-Clark.

47. *The Tech*, written four days before the exhibit opening, October 20, 1967, 1.

48. Andersen interview, July 13, 2009.

49. Lev, "Balloon Problems Mar Haacke Exhibit Opening," 11.

50. Mechsler, "Haacke to Exhibit Kinetic Art," 5. This first of the *Tech's* many articles on the one-person show did not reflect in the headline what the body of the article documented, e.g., the switch from "kinetic" to "systems" art.

51. *The Tech*, October 20, 1967, 1.

52. *The Tech*, October 20, 1967, 3.

53. Haacke's foam works were abandoned early on, perhaps because of his awareness that David Medalla had already begun to exhibit "bubble mobiles" in 1964. In Medalla's *Signals* newsletter (London), June–July 1965, an earnest letter from the young Haacke notes "it would be extremely petty and unfair if I would not say that you build [*sic*] your bubble-mobiles before I made my water-columns foam. . . . It is an old story that rather similar things are being developed at the same time by different persons spread all over the world." Haacke letter dated November 22, 1964, Köln; thanks to Anneka Lenssen for bringing this *Signals* issue to my attention.

54. Importantly, Haacke's proposal for the Scheveningen ZERO festival was not yet conceived as a system, even in the spring of 1966 when the artist excitedly wrote Burnham about the event he still thought would happen: "[A]lso, I would like to lure 1000 seagulls to a certain spot (in the air) by some delicious food so as to construct an air

sculpture from their combined mass." Letter from Haacke to Burnham, as cited by Burnham in "Hans Haacke Wind and Water Sculpture," 14. By the time of its realization off the beach at Coney Island in November 1968, the work was, definitively, a "*Live Airborne System.*"

55. Haacke was not alone in this impulse, of course, as Robert Smithson took friends on outings to New Jersey, and performance artists such as Joan Jonas and Trisha Brown began to utilize streets and rooftops for urban choreography.

56. This stock signifier of romantic beauty is interpreted radically differently by Haacke in 1968 than in the 1990s practice of Olafur Eliasson, who has studied Haacke's systems works closely. As curator Walter Grasskamp has recently described *Water in Wind's* rainbow, "this romantic aspect was rather incidental in a sequence of works of nearly scientific stringency. . . . Haacke's production had moved far away from what museums, collectors and dominant culture had made of art: a heroic mystery." Grasskamp, in Walter Grasskamp, Molly Nesbit, and Jon Bird, *Hans Haacke* (London and New York: Phaidon, 2004), 40–41. In contrast, by titling his interior mist-and-light assemblage as *Beauty* (1993), Eliasson locates the romantic history of aesthetics in the singular plural of the spectator's body: after all, both beauty and rainbow exist only in the eye of the beholder, analogized to the camera that is its "objective" correlative.

57. "By displaying the Krefeld Sewage Plant's murky discharge, officially treated enough to return to the Rhine River, Haacke brought attention to the plant's role in degrading the river. By pumping the water through an additional filtration system and using the surplus water to water the museum's garden, he introduced gray-water reclamation." http://greenmuseum.org/c/ecovention/rhine.html. Haacke confirmed in an email, August 31, 2011, that at the time of the exhibition, the Krefeld sewage treatment plant was under construction but not yet functioning. See also the work of Melissa Ragain, "Homeostasis is not enough."

58. The cancellation both stalled Haacke's career and made it. For Europeans, he became a frequent emblem of the cultural freedom offered by their state-funded museums and festivals, revealing the bankruptcy of US claims to free speech; at the same time, the artist was virtually ignored by American museums (and the American market) until well into the 1980s, when he became celebrated as one of the founders of institutional critique. The issue of the cancellation has so dominated the study of Haacke's work that the present exhibition counts as revision, emphasizing as it does the earliest systems work and arguing that it was utopian and initially quite uninterested in social critique.

59. Walter Grasskamp, "Real Time," in Grasskamp et al., *Hans Haacke,* 42.

60. Imaginative reconstruction of Haacke's concept offered by Skrebowski, "All Systems Go" (2006; a revised and expanded version of a talk given in 2005 at Tate Modern's "Open Systems: Rethinking Art c. 1970").

61. Skrebowski, "All Systems Go" (2006). Skrebowski becomes even more certain with a second version of this article published in *Grey Room*, where he argues for "a fundamental continuity in Haacke's work" between the early systems and a later institutional critique, a continuity "that is occluded by any accounting of his practice as ideologically split." I am indebted to Skrebowski for creating the space for what I hope is a productive disagreement—not to argue for an "ideological split" but to position Haacke as only gradually disenchanted with an early anti-humanist engagement with systems, and continuing to invoke a bounded art system even into the later institutional critique. See Skrebowski, "All Systems Go: Recovering Hans Haacke's Systems Art," *Grey Room,* no. 30 (Winter 2008), 54–83.

62. Skrebowski, "All Systems Go" (2006).

63. Haacke has emphasized to me (email, August 31, 2011) that "the artworld is not a 'system' apart, it always has been and will be part of society at large, interacting with it. That probably became clear to me in the mid-sixties, but I had a sense of it already during the 1959 Documenta"—referring to the photographs he took of visitors, art handlers, and curators in that show (now published in Walter Grasskamp, *Hans Haacke: Fotonotizen Documenta 2, 1959,* Museum für Gegenwartskunst Siegen, 2011). Underscoring the sociological perspective he was rapidly developing in 1970 was the color-coding of the ballots in the visitors' poll at MoMA based on the paying/nonpaying status of the visitor.

64. In *David Rockefeller, Memoirs* (New York: Random House, 2002) the author mentions (without naming the artist), the political contents of Haacke's "Poll," which asked viewers if Nelson Rockefeller's position on Vietnam would affect their vote for governor in November. David Rockefeller makes it clear that this was a factor in instigating the dismissal of John Hightower from the MoMA directorship after the *Information* show ("he had no right to turn the museum into a forum for antiwar activism and sexual liberation," p. 452. This curious echo of the firing of Edward Fry at the Guggenheim should be noted.) In a conversation of August 22, 2011, Haacke recalled that the mynah bird never once managed to utter "All Systems Go!"—which fact he enjoys as the humorous proof of this particular system's failure.

65. Hans Haacke, "New York, 1967" statement, republished in Haacke et al., *Hans Haacke, For Real: Works 1959–2006* (Düsseldorf: Richter, 2006), 90.

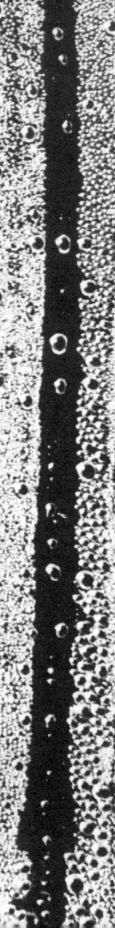

INTRODUCTION TO
THE WORK OF HANS HAACKE EDWARD F. FRY

NOTE TO THE READER

The following text was written by the art historian and curator Edward F. Fry as the introduction to a catalogue accompanying his survey of Hans Haacke's work planned for the Solomon R. Guggenheim Museum in New York in 1971. Between the MIT exhibition in 1967 and the proposed Guggenheim show, Haacke's concept of "systems" shifted dramatically from autopoetic natural and physical systems (weather, animal life cycles, aerodynamics) to include *social* systems (museum visitorship, real estate, art patronage). The content of his social systems work (in particular the tenement piece *Shapolsky et al., Manhattan Real Estate Holdings, a Real-Time Social System, as of May 1, 1971*) focused on material that the Guggenheim's director Thomas Messer found problematic. When Haacke refused to withdraw this work, the show was canceled by Messer six weeks before the opening; when Fry defended the artist's rights, he was fired. Major protests ensued, but in the end neither exhibition nor catalogue were produced. Fry's essay was translated and published in German in 1972 with a few paragraphs describing the Guggenheim cancellation; it reaches an audience in the US only now. (Fry's references to figures and artist's statements in the 1972 book have been omitted; his cover letter—presumably to the book's German publisher—is included.)

121 E 88 ST
NY NY 10028
26 February 1972

Dear Frau Thomas,

I am sending you the final materials for the Haacke book. . . .
Hans Haacke tells me that you would like to have a short statement by me about the artist and the book. I suggest the following:

"Hans Haacke works with physical, biological, and social systems. He uses Duchamp's principle of the ready-made, which he has developed to the point of achieving a new and direct means of representing the world. In his works Haacke has succeeded in changing the relationship between art and reality, and consequently he has also changed our view of the evolution of modern art."[1]

I hope that you find the additional materials sent by both myself and Haacke in good order and easy to understand. I await any further requests from you and will be happy to answer them immediately. . . .

Sincerely,

Edward F. Fry

1. [Editor's note (CAJ): The link with Duchamp may surprise the 2011 reader, but Fry was in close contact with Haacke's long-time friend and some-time mentor, Jack Burnham, who was deeply involved with Duchamp scholarship at the time. Fry was thanked for his close reading of the manuscript Burnham published as *The Structure of Art* (New York: Braziller, 1971); in it, Burnham moves from systems theories to structuralism, and devotes an entire chapter to Duchamp, with later sections of the book connecting many contemporary artists to the French Dadaist. On Haacke, Burnham writes (143): "Much of Hans Haacke's work . . . assumes the conceptual appearance of a ready-made."

Among the many issues raised with disturbing yet refreshing clarity by Hans Haacke's work are: the levels of representation in art; the possible relations between art, nature and science; the extension of Duchamp's principles regarding the found object; the present viability of symbol and metaphor in art; the possible styles of conceptual thought; the characteristics and varieties of systems including their aesthetic and representational qualities; and the relation of systems art to political and social conditions. It is Haacke's unusual gift that he is able to present such issues in works and situations possessing simultaneously allusiveness and an almost mathematical elegance and concision. As a consequence of his efforts he, like every significant artist, has extended the limits of art and has forced the re-examination of both previous art and art theory.

Born (1936) and educated in Germany, Haacke began his working career as a painter and graphic artist. By 1960, he had already mastered a painterly and graphic style which rejected figurative imagery in favor of a color-field aesthetic which, in his case, derived not only from European *tachisme* but also from his response to the paintings of [Jackson] Pollock, Mark Tobey, Yves Klein, Piero Dorazio, and the late [Piet] Mondrian.

Ce n'est pas la voie lactée, 1960.

Before leaving Germany in the autumn of 1960 on a fellowship to [Stanley W.] Hayter's Atelier 17 graphic workshop in Paris, Haacke had already become familiar with the work of the young German artists Gunther Uecker, Heinz Mack, and Otto Piene, three members of the Düsseldorf-based Group ZERO. Haacke had also begun correspondence with Piene at this time and was to remain in contact with Group ZERO for the next half decade, often participating in Group ZERO exhibitions. The influence of Uecker's nail reliefs, Mack's reflecting reliefs, and Piene's drawings is evident in Haacke's own drawings, graphics, and constructions of 1961 and 1962. The graphics Haacke executed in Paris and later in Philadelphia and New York, with their regularized, often internally structured matrices of raised dots, either white on white or yellow on white, are a fairly direct reflection of the matrix compositional systems used by Uecker and Piene.[1] The use of a matrix, with its obvious relation to Haacke's previous involvement in color-field painting, would appear directly in his structural reliefs of 1961–62 and in certain of the water boxes of 1962–64; but as a means of giving an intellectual order to experience, the matrix has remained with Haacke for much of his artistic career.

While in Paris during 1960 and 1961, Haacke become more familiar with the work and activities of Yves Klein;

but as he was later to realize with the transcendental mysticism of Piene, as in Piene's *Light Ballet*, Klein's ideas were of use to him at this stage only to a minor degree, and were for Haacke much too involved with literary values and romantic gestures.[2] Haacke at this point began to feel the necessity for a more rigorous and objective approach to experience than was available to him either through Group ZERO or through the activities of Klein and his followers. It was of importance in this regard that Haacke came into contact with the sculptor [Vassilakis] Takis in Paris, who was one of the very few Europeans of the period to make direct use of actual physical forces, i.e., magnetic fields and electrical energy. (In the same way, the wind-driven mobiles of [Alexander] Calder and, later in the 1960s of George Rickey, were to confirm Haacke's orientation toward real and verifiable phenomena.)

Arriving in the United States in the autumn of 1961 as a Fulbright Fellow at Temple University in Philadelphia, Haacke worked both in Philadelphia and New York, to which he moved in 1962, on ZERO-derived prints and relief constructions which were shown in a series of exhibitions in late 1962. While in Philadelphia he also met the artist and theoretician J[ack] W. Burnham, with whom Haacke later developed a systems approach to art that would be of use and importance to both individuals.

The implied motion caused by retinal fatigue in Haacke's graphics, and the even greater perceptual and actual motion occasioned by his mirror reliefs, caused him to adopt water as a medium at the end of 1962 in New York. After having experimented unsuccessfully with Plexiglas as a means of achieving kinesthetic visual effects, Haacke made his first "dripper" box, a *Rain Tower*. Using the natural force of gravity in a way identical

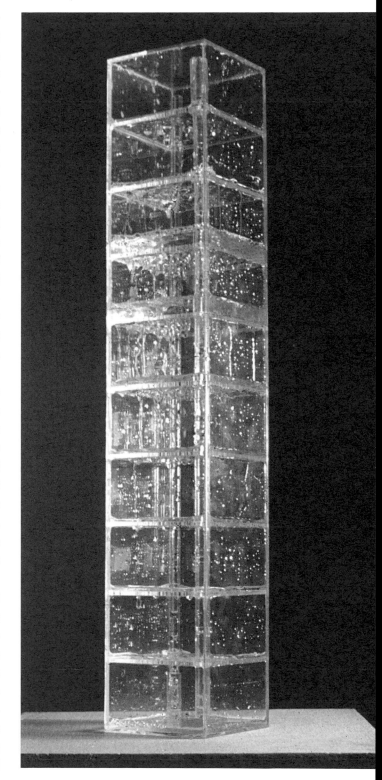

Rain Tower, 1962.

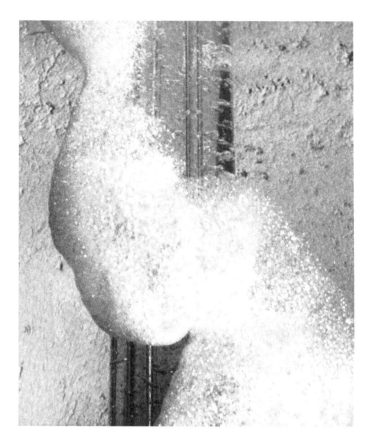

Foam experiment, detail, Haacke's Cologne studio, 1964.

to that seen in an hour glass, Haacke constructed a series of horizontal dividers, each punctured by a regular matrix of holes, through which water descends from one level to another. The observer inverts the work for the process to repeat itself. Thus in a single step Haacke achieved real motion based on natural laws, and also involved the spectator directly through physical action. These dripper boxes, of which the artist constructed numerous variations from 1962 to 1964, were also the first examples of Haacke's subsequently unbroken precept of using natural laws and phenomena in ways analogous to nature itself, but also in ways which avoid metaphorical or other literary connotations with respect to nature. Rather than making references to nature, Haacke had begun to work directly with nature as his medium.

It was at this point that he became essentially free from exterior art historical influences and began to follow the dialectical logic of experimentation and conclusions drawn from his own work alone. Thus the condensation boxes developed directly from his observations of the "dripper" boxes. The first condensation box, made early in 1963 in New York, was a far greater innovation than Haacke himself at first realized, although before leaving New York to return to Germany he was aware that he had made a significant break with not

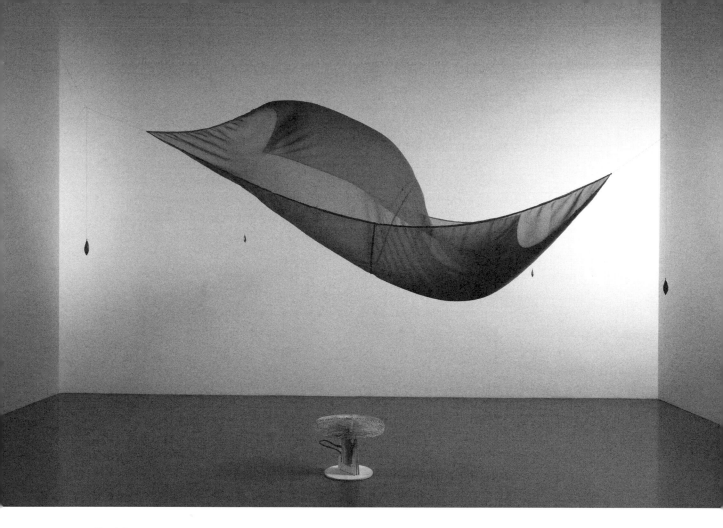

Blue Sail, 1964–65.

only his own previous work but the entire previous history of art. Haacke's condensation boxes are among the first examples of a real time open system[3] as a work of art. Having established the conditions under which water can evaporate and condense in response to changes in light and wind currents in the environment, the artist has in effect signed his name to a universal phenomenon of nature, isolated it, yet permitted it to function in its normal fashion—independent of further human intervention and with an existence of its own. The weather boxes, as Haacke so aptly called them, thus extend the Duchampian concept of the ready-made to include, at least potentially, any real phenomenon in the world: anything as a result of which the artist might choose to "articulate something natural."[4] The difference between Haacke's appropriation of phenomena and the ready-mades of Duchamp lies in the fact that Haacke's phenomena maintain a double identity: once isolated and "signed" by the artist, they nevertheless continue in their original functions, whereas Duchamp's objects lose their original function after having been placed into an aesthetic context. (Though Haacke had seen Duchamp's *oeuvre* in Philadelphia as early as 1961, he did not become aware of the relationship of his own systems to the ready-mades until 1969.) Haacke's systems, in fact, only enter into the realm of art because they operate

as representations of aspects of the world—being those aspects themselves—and because Haacke chooses to present them within an artistic context.

Before returning to Germany in the autumn of 1963, Haacke had become interested in the properties of air and air currents, realizing that in many ways both water and air could be approached from the same point of view. From the end of 1963 until 1966, after his return to New York [in 1965], Haacke worked simultaneously on situations involving air and liquids. He hung a feather on a string, allowing it to respond to air currents; combined air and water with the generation of soap bubbles; and made a large number of works involving enclosed liquids, all of which required the participation of the viewer to activate them. In some works, two liquids of differing specific gravity would be forced to exchange relative positions. In others, intervention by the viewer set up motions of varying speed, depending on the work in question; in all cases however, Haacke utilized natural laws, and, as with the dripper boxes, involved the viewer directly with the functioning of the work.

The experiments with air, on which Haacke worked concurrently with the preceding projects, began in his mind in Paris two years previously when he had been deeply impressed by Yves Klein's immaterial and non-object oriented approach to making art.[5] Haacke had brought back from New York a rubber weather balloon and soon was able to suspend it and subsequent balloons upon an immaterial stream of air. Using the same source of focused air current—a motor-driven fan—he also created other situations of unstable equilibrium, including a length of silk held vertically aloft by an air current. In later versions of these ideas he used a small parachute instead of a balloon; an ultimate consequence of these works was his outdoor project involving a long string of helium filled balloons which, supported by a gas lighter than air, nevertheless responded to the prevailing winds as did the spheres suspended above a fan, with the important difference that in a less structured, natural setting the string of balloons moved within a wider and less predictable range of behavior. Two further experiments during 1964 with air-filled bags culminated in one of Haacke's most satisfactory air projects of the period, *Blue Sail* of 1965 [p. 33], in which the range of unpredictable movement within a prearranged situation far exceeded his previous works involving air currents. A final extension of his involvement with wind and cloth was his two versions of *Narrow White Flow* of 1967–68, in which the unpredictability of motion within a cyclically structured context was transferred to a situation in which a length of silk lying on the floor responds to currents of air passing horizontally beneath it. A work exactly paralleled in conception to *Narrow White Flow*, using a different (electrical) set of physical circumstances to achieve the same cyclic effect, was Haacke's *High Voltage Discharge—Traveling* of 1968.

In 1965 two important events took place in Haacke's career which were to have a lasting effect. The first was his inclusion in the great *Nul* exhibition in Amsterdam, which brought together all those artists who had been working in areas beyond formalist, object-oriented art. Those present included members of the Gutai group from Osaka, Japan, who had been using real materials such as water, wind, and earth since the 1950s; European adherents to Group Zero; and others, such as [Lucio] Fontana, Takis, and George Rickey,

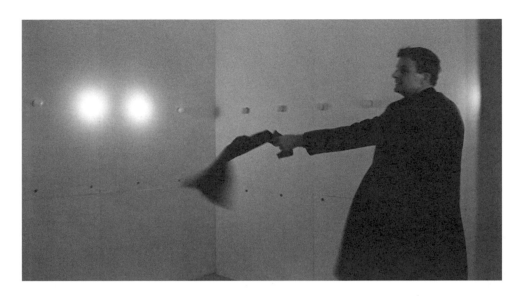

Viewer activating *Photoelectric Viewer-Controlled Coordinate System* (planned 1966), as installed at the Howard Wise Gallery in New York, 1968.

whose approaches to art were in sympathy with the post-formalist, post-object, and nature-oriented ideals of Zero. It was the first, and undoubtedly last occasion, on which such a gathering took place and probably marks the high-water mark of Zero, both as a movement and as an aesthetic.

Somewhat later in 1965 a second Zero manifestation was planned but unfortunately, practical difficulties prevented it from taking place. This was to be "Zero on the Sea," a festival of events to take place on the pier and beach at Scheveningen, Holland. In a letter of August 18, 1965, to the organizers, Haacke listed a series of projects, which included releasing 1000 bottles in the sea, containing the simple message "Zero"; floating a balloon thirty feet in diameter on the sea (and permitting it to follow the tide and winds); constructing a buoy; creating a pump-driven water geyser; arranging two jets of water so that they will oppose each other; and, most important, a proposal for "living flying sculpture with food; flocks of seagulls are concentrated at a particular point, maybe a living island."[6] This idea, which Haacke later executed in 1968 [as *Live Airborne System*], was his first step from the physical systems with which he had been engaged until then to the biological systems which would be a major preoccupation in his work of the later 1960s.

Haacke did not immediately turn to biological systems, however, upon his return to New York at the end of 1965. His next immediate project, conceived in 1966 and executed two years later, was a viewer-controlled photo-electric system in which the presence of the spectator, as with the earlier dripper and liquid boxes requiring inversion, was necessary for the work to function: as one stepped through the path of a photo-electric beam, electric lights would be illuminated on the walls of a room at positions corresponding to the coordinates of the participant's place within the room.

Fog, Swamping, Erosion, 1969.

A principal emphasis however, in Haacke's work during the latter half of the 1960s was on meteorological effects—heat, cold, and other physical phenomena—almost all of which possessed the common denominator of water and its properties in one form or another. Most of these later works can therefore be understood as elaborations and developments of the implications posed by Haacke's earlier condensation boxes. One of his original departures from the condensation box (in Cologne, 1964–65) was to place dry ice *inside* the box so as to cause condensation on the exterior rather than within it. Haacke realized that a more satisfactory arrangement was necessary, and in 1966 in New York he constructed his *Ice Stick*, using electrically powered refrigerating equipment.[7] Like the condensation boxes, this work responds to its environment; a thicker or thinner, harder or softer layer of ice forms upon the stick depending on the temperature and humidity of its surroundings. Haacke expanded the context of this open system and turned it into a subsystem by adding a source of steam, which when placed nearby would "communicate" at a distance with the ice table.[8] A more sophisticated version of this symbiotic ice and steam work was executed in 1969. The *Floating Ice Ring* of 1970 represents a further variation on the principle of the *Ice Stick*; a cooling element is submerged in water, and as ice forms, depending on conditions of temperature and humidity, the ice ring floats upon the water and also changes in thickness and surface texture.

On December 15, 1968, Haacke invited the public to the roof of his studio in New York to witness a work entitled *Wind in Water*. The work was to be whatever meteorological condition occurred on that day, which was snow, and the meteorological records documenting that day. The work having become *Wind in Water: Snow* thus represented Haacke's most extreme extension up to that time of the principle of the Duchampian ready-made. The artist has in effect signed a phenomenon of nature without having in any way intruded upon it, the only interference with natural processes being their identification and isolation through the selection of a given day.[9] A similar framing of environmental phenomena was his *Recording of Climate in Art Exhibition* of 1970, in which the phenomena themselves, being the invisible properties of temperature and barometric pressure, were recorded over a period of time. Another natural phenomenon which Haacke isolated as a ready-made was his recording of the result of precipitation and evaporation, in 1969 at Seattle. Though this, like the previous works, is a ready-made, it is also an unusually clear example of a real time system; as the end result of a real time system, *Wind in Water: Snow* was not, save for the experience of those observing it.

Analogous to the meteorological records of *Wind in Water: Snow* is a trench dug by the artist in snow parallel to the tide line at Coney Island. The trench and the photograph of it function as the record of a moment in a topographical real time situation created by water, tide, and the melting of snow. A similar relationship of phenomenon, artist's intervention, and ephemeral physical record preserved photographically is also the case with the *Monument to Beach Pollution*, 1970.

In late 1968 and early 1969 Haacke executed a series of works involving water and ice in which the artist intervened to a greater or lesser extent with natural phenomena. In some instances he simply created the circumstances following which the processes of freezing and melting of water could proceed without further intervention [*Spray at Ithaca Falls; Cast Ice*]; in another case, he only observed a phenomenon of natural occurrence [*Wind in Water: Snow*]. The difference between these two sorts of projects is that between an assisted and unassisted ready-made. In these, as in comparable instances, photographs function as an integral part of the work. The works always function both as phenomena and as records of phenomena during a passage of time; but, where the phenomenon lacks equilibrium and is ephemeral (if repeatable) both in itself and therefore as a record of itself, a photograph becomes essential.

Also during 1968 and 1969, Haacke was exploring natural phenomena not only in themselves as assisted or unassisted ready-mades, but also by means of simulating meteorological phenomena through artificial means. In 1968 he devised a *Wind Room*, which, like either the inclusion of

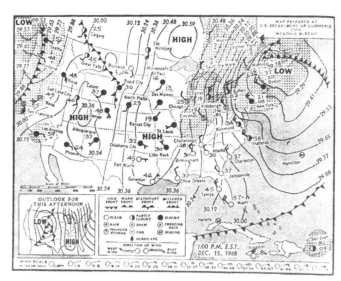

Wind in Water: Snow, December 15, 1968, staged on the roof of 95 East Houston Street (Haacke's Bowery studio), New York, including weather forecast for the day.

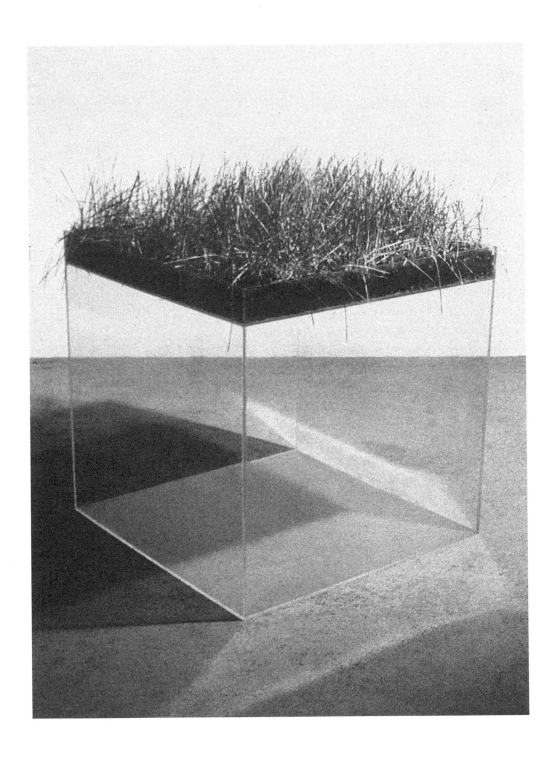

Grass Cube, 1967.

balloons or strips of cloth held aloft in his earlier aerodynamic works or the movement of spectators in his photo-electric coordinate piece, required the presence of individuals if the characteristics of an invisible phenomenon were to be perceived. He also devised two similar projects involving the invisible properties of heat and cold during this same period. Two works simulating meteorological effects even more directly were *Water in Wind* (1968) and *Weather Cycle Simulation* (1969). The latter was in effect a room-sized environmental enlargement of the earlier condensation boxes; while the former, in itself recalling the 1964 experiments with soap foam, was the actual generation of mist and fog in open space and consequently subject to the resulting effects of prevailing wind and weather. A logical extension of *Water in Wind* was the work executed at the University of Washington during the summer of 1969, again using the artificial generation of fog, but in a context where the swamping and erosion caused by water would have an effect on the environment comparable to an intensification of the already rainy climate of Seattle.

Although as early as 1965 Haacke had conceived of using biological phenomena for his works, it was in 1967 that he first executed a work based on organic life, his *Grass Cube*. At the same time, realizing that the presence of an elegant Plexiglas cube was an unnecessary element, he also planted grass in a single mound of dirt. [*Grass*, which premiered at MIT in 1967.] The historical precedents for this idea, which is an assisted ready-made, are non-existent save for an isolated yet important moment in the early work of Robert Rauschenberg.[10] In a later, conical version [*Grass Grows*, 1969], the uneven distribution of the sun's rays revealed itself in the differing rates of growth on various sides of the cone. Another project, never executed ([*Topographic Project*] 1968), was to leave a certain defined area of land in an uncultivated, untouched state indefinitely, allowing the ensuing plant life to develop on its own. An even purer example of an unassisted biological ready-made was *Bowery Seeds* (1970), in which the artist recorded photographically the plants resulting from airborne seeds taking root in a patch of earth on the roof of his studio. Haacke's photographic isolation of a hatching chicken is yet another unassisted biological ready-made.[11]

During 1969 and 1970 Haacke took a further step and began to combine biological phenomena with simulated climates. Following his project in Seattle he created at Toronto a situation in which greatly increased dampness changed the growth of the existing vegetation, a project which he repeated the following summer at Saint-Paul de Vence in southern France. As a variation on this last work he transplanted vegetation from a different climate and supported its growth in alien conditions by means of water sprayed in a fine mist. Still working with biological systems, Haacke also focused upon such real time situations as the whole process of incubation, hatching, and growth of chickens; the organization of a social system by ants in an artificial environment; the recording of turtles reacting to a displacement from their normal activities; and the activity of a goat eating vegetation along a predetermined path. Just as his project with ants, however, involved simultaneously both a biological and a social system, Haacke's isolating of a complex biological system in the birth of his own son, to whom he assigned the especially appropriate Duchampian pun "Sélavy" as a middle name, signaled his forthcoming exploration of human systems.[12]

Beginning with a project of early 1969, Haacke began to explore social systems, initially from the point of view of instantaneous information transfer. Later he isolated the news wire services as prime examples of real time systems within a larger social system; in one instance another social system, a political election, coincided with its transfer by a real time information system.

At the same time, Haacke was also expanding the scope of his approach to human social systems by using polls and questionnaires to investigate the sociological, political, and economic elements within contemporary society. His first attempt, in early 1969, was an unexecuted project for a questionnaire, to be filled out by visitors to the exhibition *Art and Technology* in Los Angeles, the results of which were to have been analyzed by computer during the course of the exhibition. In November of 1969, however, Haacke carried out a poll of visitors to his one-man exhibition in New York. The visitors were invited to indicate both their birthplace and their current residence, using colored pins on maps installed in the gallery; at the conclusion of the exhibition the accumulation of pins and their placement provided a profile of New York gallery goers.

During the summer of 1970, Haacke conducted another poll as his participation in the *Information* exhibition at the Museum of Modern Art in New York [p. 42]. This poll involved issues related to current politics and also, at least indirectly, the long association between the Rockefeller family and the museum. In this last work, a sampling of public opinion taken within an art museum was coupled to the larger social system of human politics, with its infinite economic, social, and cultural ramifications. Such systems, which involve everyone, are considered by Haacke to be not only fit subjects for his work but also systems in which the artist as a member of society may justifiably intervene, just as he had intervened in the workings of physical and biological systems in order to demonstrate their operation. A consequence of this intervention and therefore an integral part of Haacke's project was the case of the *M.O.M.A. Poll,* which provoked the reaction of such critics as Hilton Kramer and Emily Genauer who, in the name of high art and decorum, severely denounced Haacke's work in their printed reviews. Even more dramatic was Haacke's intervention, by means of objective and verifiable knowledge, in the system of commercial practices by the supposedly non-profit Fondation Maeght: on July 26, 1970, Haacke read at the Fondation the values of graphics on sale there, including the aggregate total as well as sub-totals according to individual artists, interspersing his account with other news as relayed live from the international wire services in the newsroom of the local paper. Here, as with the *M.O.M.A. Poll,* the subsequent critical reactions were a consequence of his intervention and should similarly be considered as part of the work.

Haacke prepared an extensive questionnaire for use during his one-man exhibition at the Guggenheim Museum in New York, which was to be held in May of 1971 but which was canceled by the museum when the artist refused to censor his own works. Based on a questionnaire he had devised for polling visitors during the *Software* exhibition at the Jewish Museum in New York (September–November, 1970), the Guggenheim poll was designed to reveal, with the voluntary cooperation of the visitors, both factual demographic information

and profiles of subjective values on current issues. Neither of these two polls was ever carried out.

During the summer of 1971, however, Haacke did successfully present a questionnaire[13] at the Milwaukee Art Center, where a professionally programmed computer was used to analyze the results according to percentages and to the cross-referenced socioeconomic backgrounds of those responding to the questionnaire.

Working within related areas of social systems during 1970 and 1971, Haacke demonstrated the human pollution of beaches. Another project of the same period involved a mynah bird, which Haacke attempted to train to say "All systems go" in response to the human voice. Such a work would thus become not simply a biological ready-made presented as a real time system, but also a social system through its involvement with human speech, learning patterns, and information retrieval.

Haacke's most important analyses of social systems thus far are his investigations of real estate holdings in New York City, on which he began work during the second half of 1970 [p. 43]. Using verifiable public records, the artist has documented, in the form of photographs, charts, and maps, the real estate holding systems of two of the most important individual landlords in Manhattan. The larger of the two, Sol Goldman & Alex Di Lorenzo, was found to hold 360 properties, primarily in the midtown area. The other landlord, Harry Shapolsky, was found to be the largest slumlord in Manhattan and to own 150 properties, mostly in Harlem and on the lower East Side, for which Shapolsky used a complex system of fictive or nominal ownership among friends and relatives.

The material presented by Haacke in these two real estate holding systems is, as was mentioned above, a matter of public record; and details concerning individual properties in the two systems have now been exhibited and published, as well as having been shown on CBS television in New York. The Guggenheim Museum, however, in the person of its director and certain of its trustees, refused Haacke permission to exhibit these real estate systems unless the artist suppressed all real information concerning the actual owners of properties, on the grounds that such material was "muckraking" and that it was not art. For the artist to have suppressed this information would have meant that his works would no longer be verifiable real time social systems and could not function as ready-mades, thereby violating the fundamental principles not only of the two works in question but also of Haacke's entire oeuvre. The museum thereupon cancelled Haacke's exhibition one month before its scheduled opening. The resulting furor included an artists' demonstration and boycott against the museum, the dismissal of the curator of the exhibition for having defended the artist publicly against censorship, and the appearance of dozens of articles in the American and international press. Just as in the instance of the *M.O.M.A. Poll*, the subsequent public reactions to this event became a part of the work, with the difference that Haacke's attempt to exhibit his real estate systems in the Guggenheim Museum unwittingly became part of a new work. Through his intervention by means of the real estate systems the artist was able to demonstrate the existence of yet another real time system: the functions and operative values (defense of formalist and traditional aesthetics, and

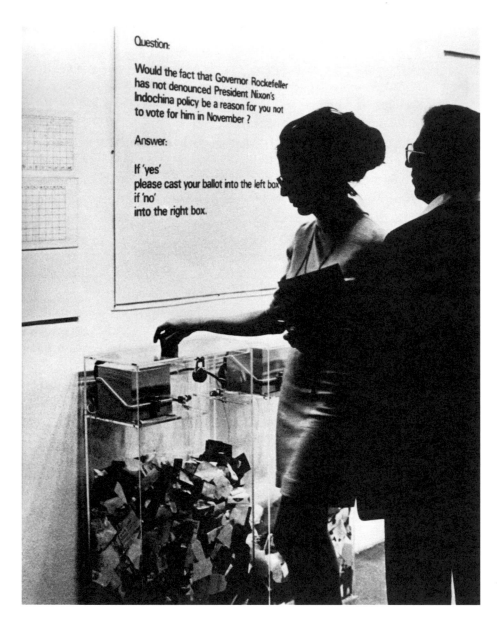

Within the image:

Question:

Would the fact that Governor Rockefeller has not denounced President Nixon's Indochina policy be a reason for you not to vote for him in November ?

Answer:

If 'yes'
please cast your ballot into the left box
if 'no'
into the right box.

MoMA Visitors' Poll (1970), installed as part of the museum's *Information* show, 1970.

maintenance of liberal political attitudes and bourgeois decorum) of American art institutions within their social context.

Haacke's most interesting works usually involve more than one system functioning simultaneously. If analyzed sufficiently, however, any of his works imply a multiplicity of systems, subsystems, and time scales—phenomena proceeding at different rates of speed. There is nevertheless no hierarchy within his fields of inquiry. Although he has in effect

Shapolsky et al., Manhattan Real Estate Holdings, A Real-Time Social System, as of May 1, 1971, as installed at the Venice Biennale in 1978.

moved from physical to biological to social systems during the past ten years, these categories often overlap; and it is usually in situations of overlap that his works of necessity attain their greatest impact. Nor has Haacke hesitated to return to earlier ideas and develop them to their further implications. Thus, in the midst of his biological projects during 1969 he was also working with ice and water; and in a work entitled *Cycle* he was in fact presenting a more dramatic and less restricted version of such early sculptures as his

Trickle Piece of 1963. Similarly, in a project entitled *Recycling* prepared for the Guggenheim Museum in 1971, as with *Circulation* of 1969, Haacke did not hesitate to return to his closed physical systems of the early 1960s. The intellectual habit of the matrix, in which all things and processes have their own value, thus manifests itself again at this point as throughout Haacke's career. It is not just a phenomenon in itself to which he has been drawn, nor the system which it may incarnate, nor the intellectual, aesthetic, or social consequences that may result. Rather it is an attempt to achieve a more direct representation of the world, based on a strict yet imaginative analysis of verifiable fact, that has been the artist's continuing motivation. In his search for the means to demonstrate the invisible but fundamental relations which underlie the nature of the world Haacke appears as far more a representational artist than many painters who, returning to traditional craft techniques and academic motifs, merely repeat old retinal habits of external representation.

Haacke's intentions have been misunderstood throughout the 1960s. At first grouped with ZERO, with whom he had undeniable affinities, he was during the mid-1960s considered a kinetic artist; subsequently he has been falsely grouped with conceptual and process artists, many of whose recent ideas he himself had carried out long previously and in other contexts. Having drawn upon a Duchampian heritage, however, only to reorient it to the purpose of an ever more direct representation, Haacke completes a long evolution within the history of Western art and culture, at the beginning of which art was closely linked to various other human activities as a means of dealing with the realities of life in this world. Coming at the end of a modern tradition in which art was relegated to a privileged but specialized and often highly esoteric social function, the approach to reality offered by Haacke acts not only as a severe critique of previous modern art, but also serves to eliminate arbitrary boundaries within our culture between art, science, and society. Haacke's way of representing the world offers an alternative to subjective limits as well, for he has consistently moved toward the elimination of ego as a guide to the apprehension of reality.

As an artist, he is perhaps even more subversive than Duchamp, for Haacke so treats his own ready-mades that they remain systems representing themselves and therefore cannot be assimilated to art. Thus he violates the mythic function, to which art has long been assigned, of acting as a buffer between man and the nature of reality. His work instead presents a direct challenge, not only to the fatal but convenient bourgeois separation of art from life, but also to the related view that art functions as a symbolic transformation and interpretation of experience. Haacke's world is rigorously materialist, not symbolic, but his materialist view is of such large dimensions and possesses a logic and truthfulness of such clarity that it reaches the level of an almost transcendental moral force: rather than setting limits to consciousness, he offers a new freedom.

NOTES

1. [Ed. note: Piene termed these "*Rasterbild*," referring to the iterative mechanical processes that moved back and forth across textiles or other materials in factory production. "Raster" came to be more widely used to describe the electron beam constituting the image in television screens and early computer monitors.]

2. The historical importance of Klein's contributions to the heritage of Duchamp, however, as well as the precedents established by Klein's use of air, fire, and water for Haacke's own later work, cannot be denied.

3. A real time system is any phenomenon which is observable as it takes place; an open system differs from a closed system in that it can respond to information outside of itself, whereas a closed system does not, i.e., it simply repeats itself without variation. Haacke only became aware of a systems approach to his own work later in the 1960s, partly through his contacts with J. W. Burnham. Yves Klein's famous trip from Paris to Nice with a painting attached to the roof of the car is an immediate precedent to Haacke's condensation boxes, although with an important difference. The effects of wind, sun, and rain on Klein's painting may be called the record of a real time system, as was the geometry book suspended outside a window according to Duchamp's instructions. In both cases, however, one is confronted with the record of a real time system, not the presence of the working system itself; and also in both cases the system recorded is the result of an arbitrary act, rather than an attempt to demonstrate the nature of the physical world.

4. [Ed. note: The quote is from a statement by Haacke written in Cologne 1965, first published in conjunction with a gallery exhibition in Düsseldorf. It was used by MIT as part of its poster for the 1967 Haacke show, and was reprinted yet again by Fry on page 24 of *Hans Haacke, Werkmonographie* ([Cologne]: M. DuMont Schauberg, 1972).]

5. In 1958 Yves Klein had planned several works combining air, climate, and a romantic conception of future architecture.

6. [Ed. note: At this quote Fry noted "(translated from the German original)," indicating that he had obtained a copy of Haacke's letter to Verboon and Vogel, the organizers of the event headquartered at "Galerij Orez" (Zero, backwards) in the Hague.]

7. [Ed. note: Shown at MIT in October 1967.]

8. [Ed. note: Although Fry has been discussing *Ice Stick*, he transitions at the end of this sentence into a discussion of *Ice Table*, a rarely seen work from 1967 that may no longer be extant, but which is illustrated in *Werkmonographie* as figure 37, just under the work *Steam* from the same year.]

9. Yves Klein had wished as a boy, in 1946, to sign the blue sky as a work of art.

10. Rauschenberg decided to exhibit in September 1953, at the Stable Gallery in New York, a packed mass of earth in which some bird seed had germinated. In Paris in 1967, however, the French-Polish sculptor Piotr Kowalski also made a conical mound of earth planted with grass; the mound was designed to rotate slowly by a motor drive, so as to affect the direction of plant growth through centrifugal force. Neither Rauschenberg nor Kowalski, however, seems to have realized the further possibilities of their experiments and both returned afterwards to somewhat more conventional media.

11. [Ed. note: "Unassisted" is a complex characterization of this piece, since the chickens are hatched in a precisely calculated sequence using the incubator.]

12. [Ed. note: Fry illustrated the "work" in question, *Note to Carl Samuel Sélavy Haacke*, a birth certificate from New York University Hospital stamped "Collaboration Linda & Hans Haacke."]

13. Copyright Hans Haacke and the Milwaukee Art Museum.

ARTIST STATEMENTS HANS HAACKE

. . . make something which experiences,[1] reacts to its environment, changes, is non-stable . . .

. . . make something indeterminate, which always looks different, the shape of which cannot be predicted precisely . . .

. . . make something which cannot "perform" without the assistance of its environment . . .

. . . make something which reacts to light and temperature changes, is subject to air currents, and depends, in its functioning, on the forces of gravity . . .

. . . make something which the "spectator" handles, with which he plays, and thus animates . . .

. . . make something which lives in time and makes the "spectator" experience time . . .

. . . articulate something Natural . . .

—Cologne, January 1965, written in German and published May 1965 by Düsseldorf Galerie Schmela; first published in English March 1965 in *NUL 1965* (Amsterdam: Stedelijk Museum). Republished as poster for MIT exhibition October 1967.

———

If wind blows into a light piece of material, it flutters like a flag or it swells like a sail, depending on the way in which it is suspended. The direction of the stream of air as well as its intensity also determine the movements. None of these movements is without an echo from all the others. A common pulse goes through the membrane. The swelling on one side makes the other side recede; tensions arise and decrease. The sensitive fabric reacts to the slightest changes of air conditions. A gentle draft makes it swing lightly; a strong air current makes it swell almost to the bursting point or pulls so that it furiously twists itself about. Since many factors are involved, no movement can be precisely predicted. The wind-driven fabric behaves like a living organism, all parts of which are constantly influencing each other. The unfolding of the organism in a harmonious manner depends on the intuitiveness and skill of the "wind player." His means to reach the essential character of the material are manipulations of the wind sources and the shape and method of suspending the fabric. His materials are wind and flexible fabric; his tools are the laws of nature. The sensitivity of the wind player determines whether the fabric is given life and breathes.

—Cologne, August 1965, written in German and first published in *Hans Haacke: Wind und Wasser* (Berlin: Haus am Lützowplatz, 1965). First English publication in Jack W. Burnham, "Hans Haacke: Wind and Water Sculpture," *Tri-Quarterly Supplement,* no. 1 (Spring 1967).

I have partially filled Plexiglas containers of a simple stereometric form with water and have sealed them. The intrusion of light warms the inside of the boxes. Since the inside temperature is always higher than the surrounding temperature, the water enclosed condenses: a delicate veil of drops begins to develop on the inside walls. At first, they are so small that one can distinguish single drops from only a very close distance. The drops grow—hour by hour—small ones combine with larger ones. The speed of growth depends on the intensity and the angle of the intruding light. After a day, a dense cover of clearly defined drops has developed and they all reflect light. With continuing condensation, some drops reach such a size that their weight overcomes the forces of adhesion and they run down along the walls, leaving a trace. This trace starts to grow together again. Weeks after, manifold traces, running side by side, have developed. According to their respective age, they have drops of varying sizes. The process of condensation does not end. The box has a constantly but slowly changing appearance which never repeats itself. The conditions are comparable to a living organism which reacts in a flexible manner to its surroundings. The image of condensation cannot be precisely predicted. It is changing freely, bound only by statistical limits. I like this freedom.

—New York, October 1965, written in German but first published in French in *Robho* (Paris), no. 2 (November/December 1967). First English publication in *Hans Haacke: Obra Social* (Barcelona: Fundació Antoni Tàpies, 1995).

A "sculpture" that physically reacts to its environment is no longer to be regarded as an object. The range of outside factors affecting it, as well as its own radius of action, reach beyond the space it materially occupies. It thus merges with the environment in a relationship that is better understood as a "system" of interdependent processes. These processes evolve without the viewer's empathy. He becomes a witness. A system is not imagined, it is real.

—New York, September 1967, written in English and first published in announcement of solo exhibition at Howard Wise Gallery, New York, January 13–February 3, 1968.

In talking about nature, we most often think only in terms of trees, the blue sky, etc.,[2] and not of the underlying forces and patterns of organization. Neither do we immediately realize that these same conditions are at the basis of all technological achievements. An airplane is subject to the same aerodynamic laws as is the seagull. We seem to be so accustomed to looking more at the "gestalt" of natural phenomena and to interpreting it in a heart-warming, romantic manner, that we neglect perceiving the physical laws forming the "gestalt."

—New York, September 1967, written in English and quoted in Bitite Vinklers, "Hans Haacke," *Art International* 13:7 (September 1969).

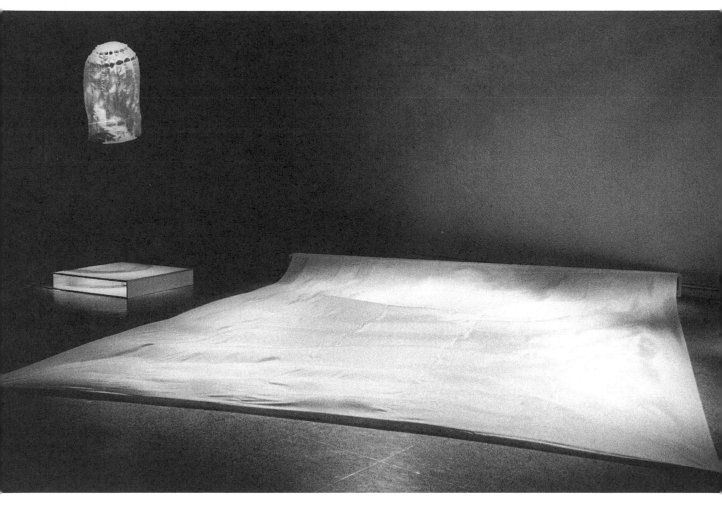

Installation view of Haacke's show at MIT, 1967.

The label "Kinetic Art" has been widely used, implying that there is a recognizable school style, trend, fad, or "movement" with definite characteristics. I am suspicious about this label, for I have doubts about the proclaimed common basis for all examples of so-called "Kinetic Art." The only common denominator, naturally, would be that something moves. [. . .] There are various degrees of incorporating movement into three-dimensional work, i.e., movement could be an additional factor or its very essence. [. . .] It would therefore be more revealing (but would also require more insight on the part of the art packaging agents) to establish relationships along other lines. This would indicate that certain "kinetic" work has more in common with static objects than with other "kinetic" work and vice versa.

—New York, September 1967, written in English and published only in German in Edward Fry, *Hans Haacke: Werkmonographie* (Cologne: M. DuMont Schauberg, 1972).

Cast Ice, Freezing and Melting, February 1969 (Bowery studio rooftop, New York).

———

The concept of "systems" is widely used in the natural and social sciences and especially in various complex technologies. Possibly it was Jack Burnham, an artist and writer, who first suggested the term (not to be confused with "systemic") for the visual arts. By its use, he was trying to distinguish certain three-dimensional situations, which, misleadingly, have been labeled as "sculpture."

A system is most generally defined as a grouping of elements subject to a common plan and purpose. These elements or components interact so as to arrive at a joint goal. To separate the elements would be to destroy the system. Outside the context of the whole, the elements serve no function. Naturally these prerequisites are also true of every good painting, sculpture, building, or similarly complex but static visual entity. The original use of the term in the natural sciences is valuable for understanding the behavior of physically interdependent processes. It explained phenomena of constant change, recycling, and equilibrium. Therefore, I believe there are sound reasons for reserving the term "system" for certain non-static "sculptures," since only in this category does a transfer of energy, material, or information occur. [. . .]

The physical self-sufficiency of such a system has a decisive effect on the viewer's relationship to the work, due to its hitherto unknown independence from his mental involvement. His role might be reduced to being the source of physical energy in works conceived for viewer participation. In these, his actions—pulling, pushing, turning, etc.—are part of the program. Or his mere presence might be sufficient. However, there are systems which function properly even when the viewer is not present at all, i.e., their program operates absolutely independently of any contribution on the part of the viewer.

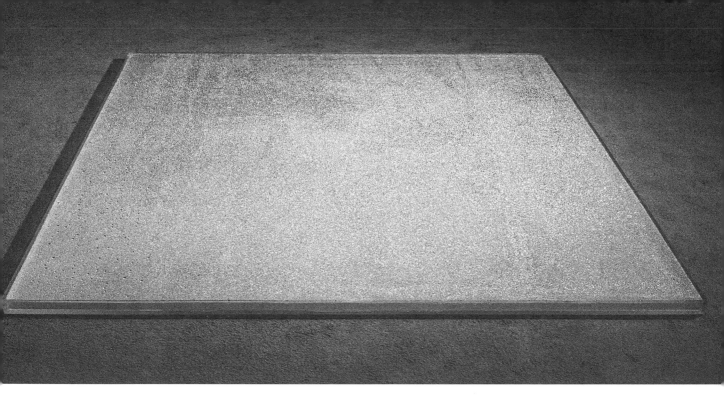

Condensation Floor, 1963–66.

Whether the viewer's physical participation is required or not, the system's program is not affected by his knowledge, past experience, the mechanics of perceptual psychology, his emotions or degree of involvement. In the past, a sculpture or painting had meaning only at the grace of the viewer. His projections into a piece of marble or a canvas with particular configurations provided the program and made them significant. Without his emotional and intellectual reactions, the material remained nothing but stone and fabric. The system's program, on the other hand, is absolutely independent of the viewer's mental participation. It remains autonomous—aloof from the viewer. As a tree's program is not touched by the emotions of lovers in its shadow, so the system's program is untouched by the viewer's feelings and thoughts. The viewer becomes a witness rather than a resounding instrument striving for empathy. [. . .]

—New York, September 1967, written in English and published only in German in Fry, *Werkmonographie*, 1972.

———

A blanket of snow may be used like paper or canvas on which marks and traces can be made. Snow also lends itself as inexpensive, although ephemeral construction material for shape-oriented sculpture. Neither approach goes essentially beyond what is traditionally conceived of as painting or sculpture.

Another attitude, however, would be to consider snow as part of a large meteorological system determined by humidity, temperature, air pressure, velocity, and direction of winds as well as topographical characteristics of the earth. All of these factors are interrelated and affect each other. Taking such an attitude would lead to working strategies that could expose the functioning and the consequences of these interdependent processes.

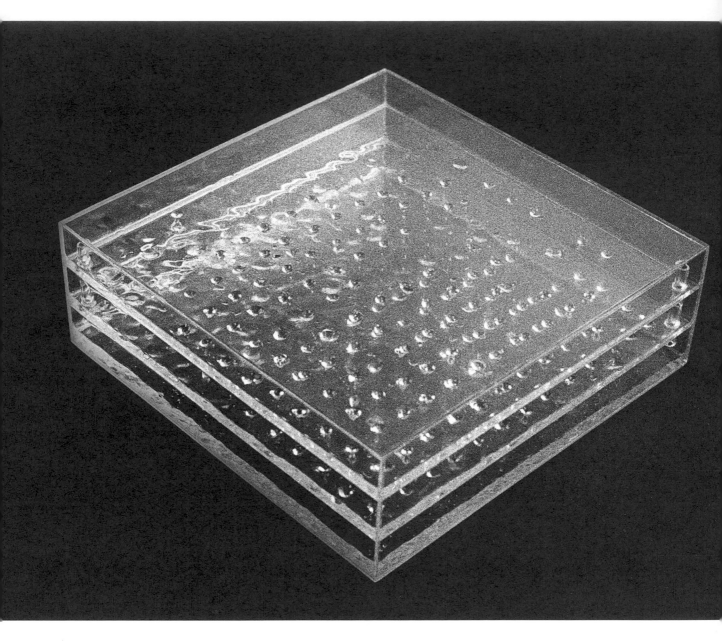

Double Decker Rain, 1963.

For a formalist the resulting situations would appear as just another black-and-white drawing or three-dimensional composition to be judged according to standard rules of formal accomplishment. However, formal criteria bypass the systems concept and are therefore irrelevant. [. . .] The shape of the snow mass is of no interest for the revelation of the meteorological system.

Naturally a systems oriented approach is not only capable of handling topographic or meteorological situations. It deals with the very functioning of our total environment as "an interlocking complex of processes characterized by many reciprocal cause-effect pathways" (Kenneth E.F. Watt).[3] Such a program excludes traditional criteria of judgment. Of course, it is the new works, not the old productions, which embody an appropriate value system. At this moment, however, it would be a waste of energy to get bogged down in codifying it. This job should be left to the academicians.

—New York, February 1969, written in English and excerpted in Ursula Meyer, ed., *Conceptual Art* (New York: E.P. Dutton: 1972).

———

The working premise is to think in terms of systems; the production of systems, the interference with and the exposure of existing systems.

Such an approach is concerned with the operational structure of organizations, in which transfer of information, energy, and/or material occurs. Systems can be physical, biological, or social, they can be man-made, naturally existing, or a combination of any of the above. In all cases verifiable processes are referred to.

—New York, 1969, written in English and first published in announcement for *Hans Haacke,* Howard Wise Gallery, New York, November 1969.

NOTES

1. When used (and repeated) in the poster for Haacke's one-person show at MIT in 1967, the word "experiences" was omitted; ellipses were converted to caps and periods.
2. When translating this statement for publication in German, Haacke added "Bergen" to the list—mountains functioning as a prime signifier of the German Romantic tradition he wanted to oppose.
3. The reference is probably to Kenneth E.F. Watt, ed., *Systems Analysis in Ecology* (New York: Academic Press, 1966).

EPHEMERAL WORKS　　　　HANS HAACKE

Zero on Sea, proposal drawings sent by Haacke to organizers Verboon and Vogel, August 18, 1965.

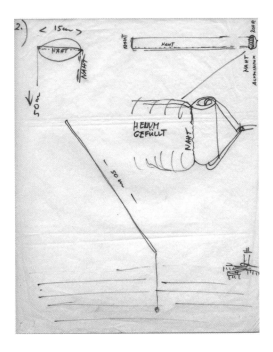

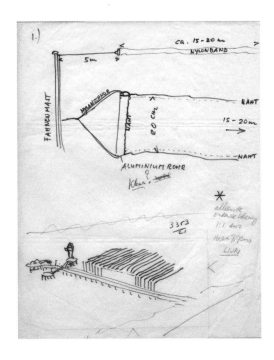

Zero on Sea, proposal drawings sent by Haacke to organizers Verboon and Vogel, August 18, 1965.

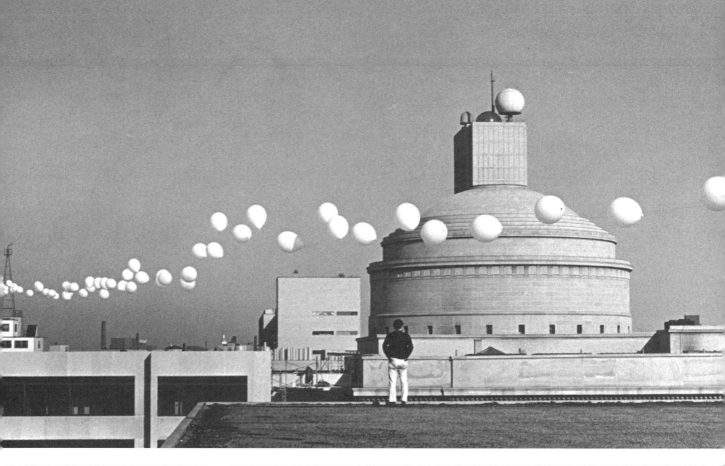

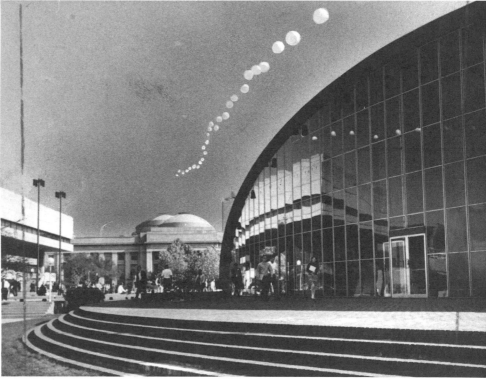

Photographs documenting *MIT Sky Line*, October 24, 1967; unlike all other images in this section, this documentation was not produced by Haacke. Images courtesy of the MIT Museum (top and left, *Tech Talk*; right, *The Boston Herald*, marked for cropping).

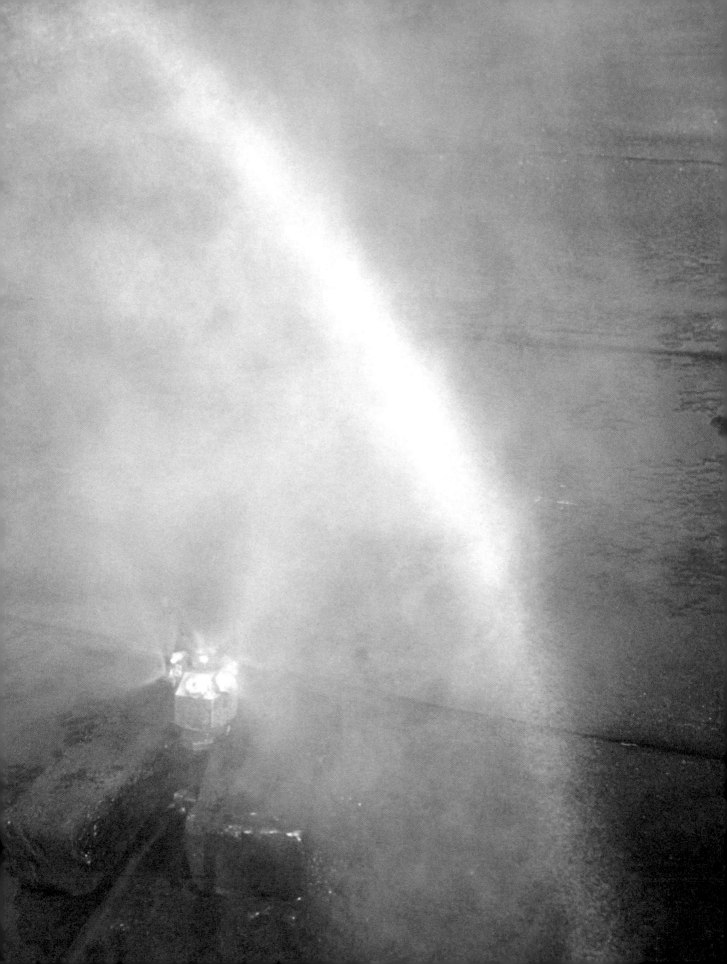

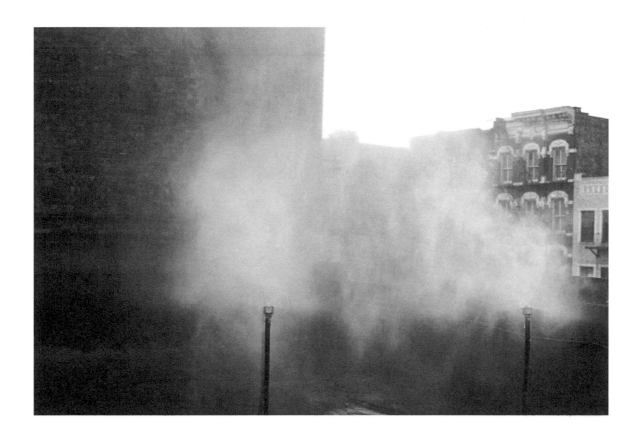

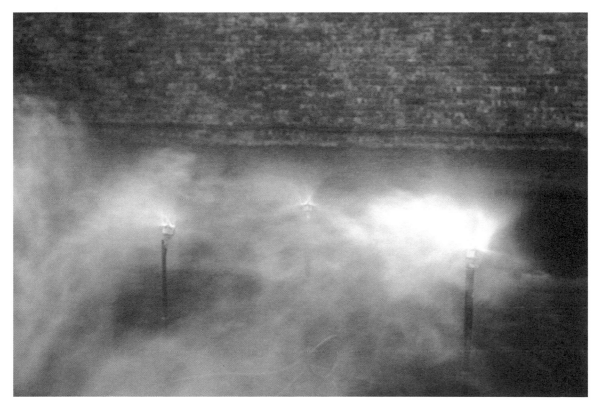

Water in Wind, 1968 (on the artist's studio rooftop at 95 East Houston Street, New York).

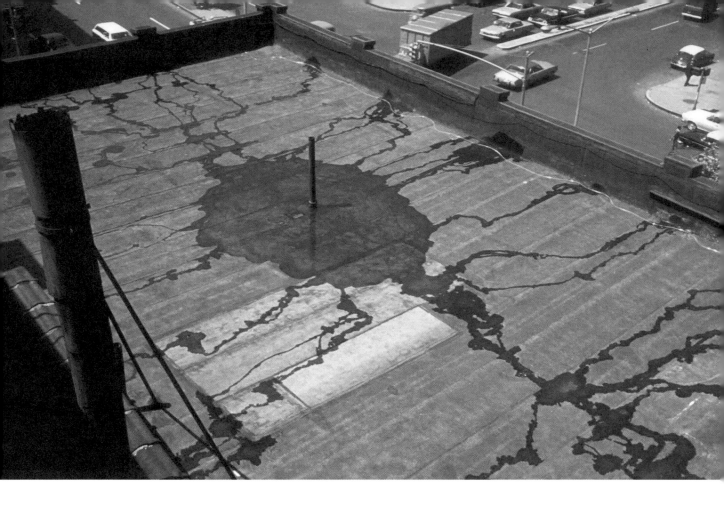

Cycle, 1969 (95 East Houston Street, New York). Below: *Snow Pile*, 1969 (95 East Houston Street, New York).

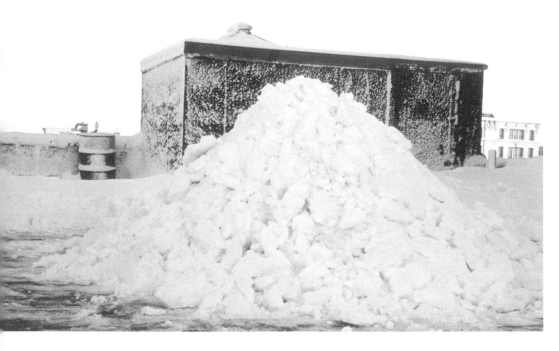

Cast Ice, Freezing and Melting, February 1969 (95 East Houston Street, New York).

Below: *Spray of Ithaca Falls: Freezing and Melting on Rope, February 7, 8, 9 . . . 1969* (Ithaca, New York).

Live Airborne System, November 30, 1968 (Coney Island, New York). Below: *Ant Co-op*, 1969 (Howard Wise Gallery, New York).

Ten Turtles Set Free, July 20, 1970 (Saint-Paul de Vence, France). Below: *Chickens Hatching*, 1969 (Art Gallery of Ontario, Toronto, Canada).

Left: *Transplanted Moss Supported in Artificial Climate*, July 1970 (Saint-Paul de Vence, France).

Below and right: *Artificial Rain*, July 1970 (Saint-Paul de Vence, France).

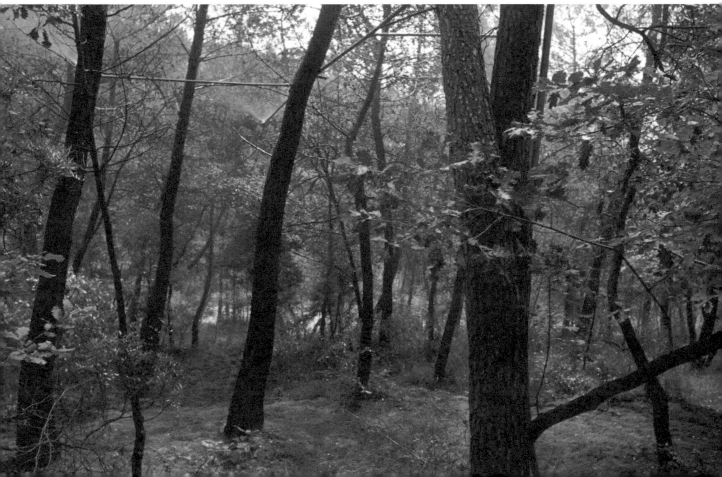

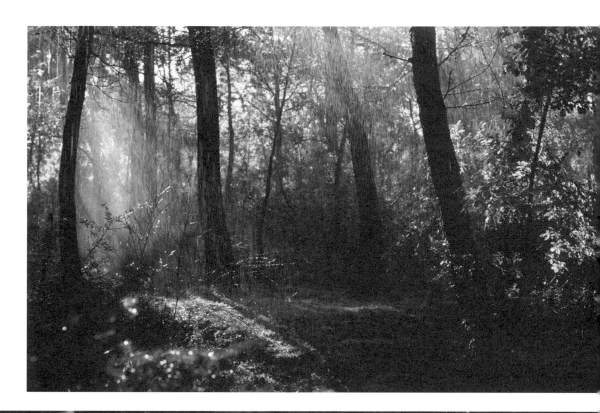

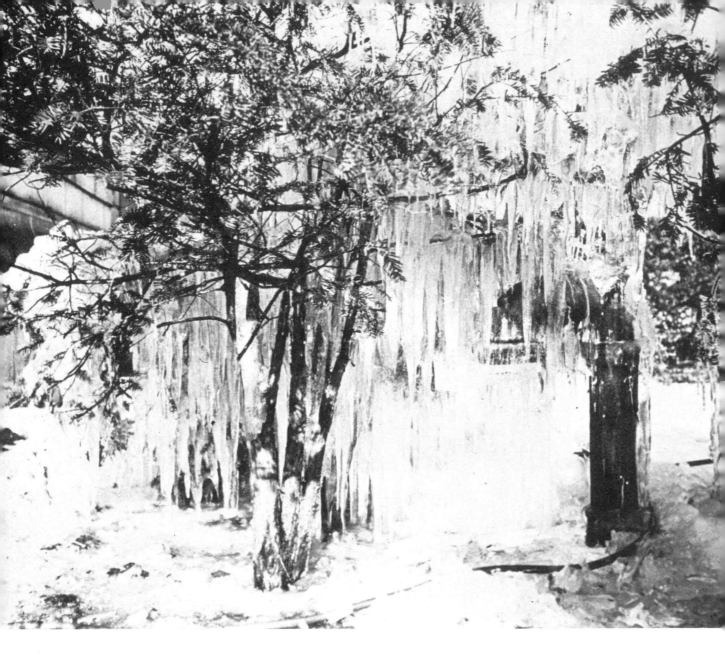

Fog, Dripping, Freezing, 1971 (Museum of Fine Arts, Boston).

Tokyo Trickle, 1970 (Tokyo Biennial, Tokyo, Japan).

Right: *Trickle, Maenz Gallery*, 1971 (Galerie Paul Maenz, Cologne, then West Germany).

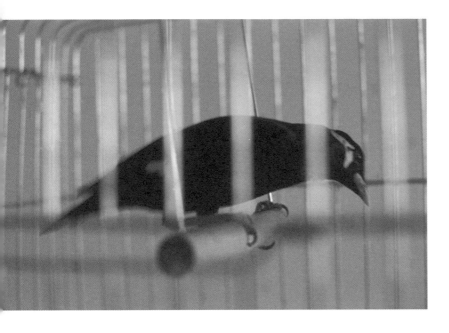

Left: *Norbert: "All Systems Go,"* 1970–71 (unfinished, planned for Solomon R. Guggenheim Museum, New York).

Right: *Guggenheim Beans*, 1971 (unfinished; Solomon R. Guggenheim Museum, New York).

Below: *Guggenheim Rye in the Tropics*, 1971 (Solomon R. Guggenheim Museum, New York).

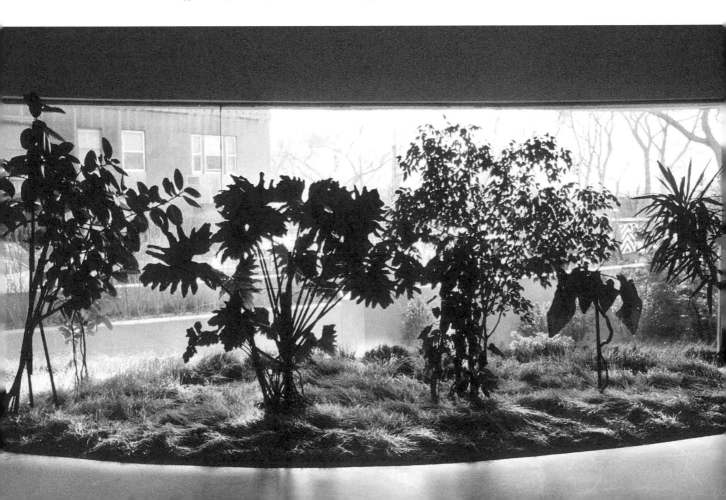

Right: *Directed Growth*, 1972 (Museum Haus Lange, Krefeld, then West Germany).

Below: *Monument to Beach Pollution,* 1970 (Carboneras, Spain).

Right: *Rhine Riverbank*, 1972 (Krefeld, Germany).

Below: *Rhine Water Purification Plant*, 1972 (Krefeld, Germany).

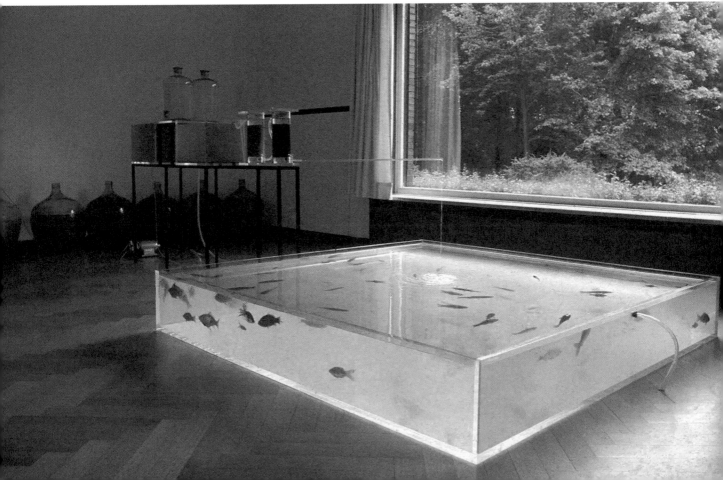

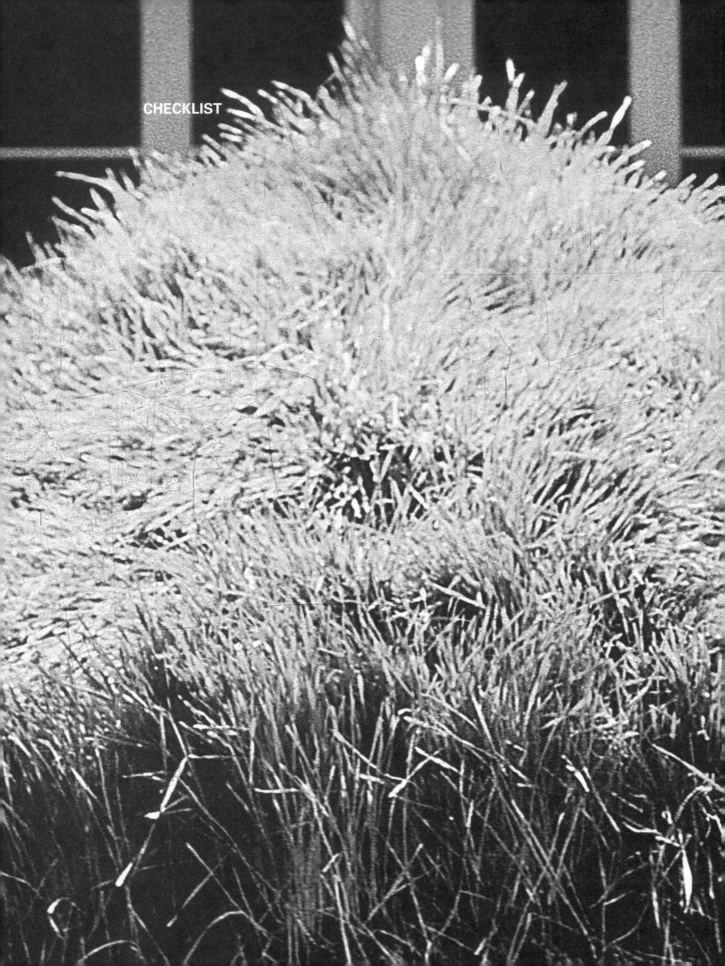
CHECKLIST

HAYDEN GALLERY

Dates of works are those of conception and execution, with the date of any subsequent versions following in parentheses, and, when applicable, separated by a slash / from date of refabrication. If a refabrication is of different dimensions, they too are separated by a slash. Unless otherwise noted, loans are courtesy of the artist.

Condensation Cube (aka Weather Cube), large version

1963–65 (small version); 1963–67 / 2006 (large version)
Acrylic plastic, distilled water, climate in area of display
30" x 30" x 30"
Courtesy of the artist and Paula Cooper Gallery

Double Decker Rain

1963 / 2011
Acrylic plastic, distilled water, viewer manipulation
13 $^7/_8$" x 13 $^7/_8$" x 5"

Condensation Floor

1963–66 / 2011
Acrylic plastic, distilled water, climate in area of display
6' x 6' x 2"

Large Water Level

1964–65 / 2011
Acrylic plastic, distilled water, ring screws, nylon cord, springs, viewer manipulation
Tube: 5' long, 3" diameter

Sphere in Oblique Air Jet

1964–67 / 2011
White latex balloon, helium, fan, laminate, wood, plastic grill, airjet
Base: 11" x 15" x 22"; balloon height approx. 60"; balloon diameter approx. 20"

Flight

1965–66 (version 1); 1967 (version 2) / 2011
Silk chiffon parachute, fan, laminate, wood, plastic grill, airjet
Parachute: 21 $^3/_4$" x 30"; base with fan: 10" x 30" x 30"

Clear Flow

1966 / 2011
Acrylic plastic, 2 immiscible liquids, viewer manipulation
10 $^5/_8$" x 4" x 20"

Ice Stick

1966
Stainless steel, copper tubing, refrigeration unit
Humidity in the area of display condenses and freezes on refrigerated copper tube.
68 $^3/_8$" x 24 $^1/_8$" x 24 $^5/_8$"
Art Gallery of Ontario, Toronto, Canada; Purchase, 1969

Grass Cube

1967
Acrylic plastic, earth, grass
Base: 3' x 3' x 3'
Courtesy of the artist and Paula Cooper Gallery

White Waving Line

1967 / 2011
Silk chiffon, fan, laminate, wood, airjet
Base: 10" x 17" x 17"; chiffon: 2' x 5'

Wide White Flow

1967 / 2006 / 2010
Silk fabric, fans, steel armature, airjet
Dimensions variable, 17' x 39'
Courtesy of the artist and Paula Cooper Gallery

Grass Grows (aka Grass)

1967–69
Earth, winter rye
First version: irregular, approx. 10' across, approx. 10" deep
Since 1969: cone shape, dimensions variable

BAKALAR GALLERY:
EPHEMERAL WORKS, 1965–72

Works listed are ephemeral projects and proposals documented in the exhibition by reproductions from digital scans of drawings, photographs, and slides. Unless otherwise indicated, images are courtesy of the artist.

ZERO on Sea
August 1965–February 1966
Typescript letters and colored-pen-on-paper drawings sent by the artist from Cologne, then West Germany (August 1965), and New York, NY (February 1966), containing proposals for a "ZERO on Sea" festival on a pier in Scheveningen, the Netherlands, planned by the Orez International Gallery in the Hague
Proposed projects include water jets in the ocean, aluminum balls set loose on the sea, banners and balloons whipping in the wind, a "Möwenplastik" (seagull sculpture), a flotilla of "Flaschenpost" (message-in-a-bottle), a labyrinth of roofed wicker beach chairs, a 50-meter-long helium balloon, and waterjets aimed under a platform to be built in the ocean.
The festival did not take place and none of the proposals were executed at the time.
Images courtesy of Archiv A. Vogel – ZERO on Sea @ ZERO foundation, Düsseldorf, Germany

MIT Sky Line
October 24, 1967
600-foot nylon cord, helium, approx. 800 latex balloons
First performed as *Sky Line* in *Kinetic Environment 1 and 2 in* Central Park, New York, April and September 1967
Executed for MIT as part of one-person exhibition at the Hayden Gallery in Cambridge, Massachusetts
Black-and-white images courtesy of the archives of the MIT Museum, MIT Committee for the Arts files

Water in Wind
1968
Spray nozzles, pump, water, wind
Executed on the rooftop of the artist's studio at 95 East Houston Street (at the corner of Houston Street and the Bowery), New York City

Live Airborne System
November 30, 1968
Breadcrumbs, sea, seagulls
Executed at Coney Island, New York, by throwing breadcrumbs out to sea to attract seagulls

Topographic Contour Project
1968
An unexecuted contribution to a proposal by the architects Berman, Roberts, and Scofidio of New York City for Fort Greene Park in Brooklyn, New York: "To leave area between two topographical contour lines of 10 feet depth uncultivated" for the lifetime of the park

Spray of Ithaca Falls: Freezing and Melting on Rope, February 7, 8, 9 . . . , 1969
Rope, water, spray, cold
Executed by stretching rope covered in wire mesh below Ithaca Falls and allowing spray to freeze and thaw over several days.
Installed as part of *Earth Art* exhibition, Andrew Dickson White Museum, Cornell University, Ithaca, New York

Cast Ice, Freezing and Melting, January 3, 4, 5 . . . February, 1969
Ice, weather
Water was trapped on the sloping roof by wooden beams, which were removed after freezing. The resulting casts melted and froze.
Executed on the rooftop of the artist's studio

Snow Pile, Melting and Evaporating February 10, 11, 12 . . . , 1969
Snow, weather
Snow collected from the roof of the artist's studio was piled up. It melted and evaporated.
Executed on the rooftop of the artist's studio

Ant Co-op
1969
Ants, acrylic plastic container, sand, food, water
First exhibited at Howard Wise Gallery, New York

Cycle
1969
Plastic tubing, water, pump, gravity
A plastic tube was perforated and arranged
around the rooftop periphery, allowing water to
trickle out, forming rivulets and flowing to the
center of the roof (the lowest point), from where
it was pumped back into the perforated tube.
Executed on the rooftop of the artist's studio

Chickens Hatching
1969
Fertilized eggs, incubators, lamps, thermostat
Installed as part of *New Alchemy: Elements,
Systems, and Forces* exhibition, Art Gallery of
Ontario, Toronto

Bowery Seeds
Summer 1970
Earth, airborne seeds
Executed by placing a pile of soil on the rooftop
of the artist's studio and allowing airborne seeds
to germinate

Ten Turtles Set Free
July 20, 1970
Turtles from a pet store were set free
Executed at Saint-Paul de Vence, France, as
part of the exhibition *L'art vivant aux Etats-Unis*,
Fondation Maeght

**Transplanted Moss Supported in Artificial
Climate**
July 1970
Moss, spray nozzles, hose and pipes, water;
transplantation of moss from nearby mountains
supported by sprinkler system
Executed at Saint-Paul de Vence, France

Artificial Rain
July 1970
Spray nozzles, hose and pipes, water, creating a
rainbow effect
Executed at Saint-Paul de Vence, France

Monument to Beach Pollution
August 1970
Slabs of construction material, plastic containers,
and other detritus collected from a 200m x 50m
stretch of beach and put in a pile
Executed in Carboneras, Spain

Tokyo Trickle
May 1970
Plastic tubing, water, gravity
A tube with holes allowing water to trickle out
and form patterns in the street
Executed at the Tokyo Biennial

Trickle, Maenz Gallery
January 1971
Plastic tubing, water, gravity
A tube with holes allowing water to trickle out,
form rivulets, and disappear in the drain hole
of the courtyard of the Galerie Paul Maenz,
Cologne, Germany

Fog, Dripping, Freezing
Winter 1971
Hose, water, cold
Water was sprayed and froze on plantings
outside the Museum of Fine Arts, Boston,
as part of the exhibition *Earth Air Fire Water:
Elements of Art*

Norbert: "All Systems Go"
1970–71
Mynah bird, cage
An uncompleted project in which a mynah bird
was trained to utter the phrase "All Systems Go"
in the Haacke exhibition planned for the Solomon
R. Guggenheim Museum, New York

Guggenheim Beans
1971
Beans, earth, twine
An uncompleted project to direct the growth of beanstalks along twine stretched from a planter on the second floor ramp to the third floor ramp of the Solomon R. Guggenheim Museum

Guggenheim Rye in the Tropics
1971
Winter rye, earth
Ryegrass sown in pre-existing planter with tropical plants on the ground floor of the Solomon R. Guggenheim Museum

Directed Growth
Summer 1972
Beans, earth, twine
Beans trained to grow at an angle in the galleries of the Museum Haus Lange, Krefeld, then West Germany, as part of the solo exhibition *Hans Haacke: Demonstrationen der physikalischen Welt: biologische und gesellschaftliche Systeme*

Rhine Riverbank
Summer 1972
Photo documentation of pollution from nearby chemical plant and of garbage on the banks of the River Rhine at Krefeld, Germany, for installation in the galleries of Museum Haus Lange, Krefeld, Germany as part of a solo exhibition

Rhine Water Purification Plant
Summer 1972
Glass and acrylic containers, pump, polluted Rhine water, tubing, filters, chemicals, goldfish, drainage to garden
A system for harvesting polluted water discharged by the city sewage system into the Rhine, purifying it, and using it to sustain live fish; the overflow of clean water was carried to the museum garden, where it seeped into the ground.
Executed at the Museum Haus Lange, Krefeld, Germany as part a of solo exhibition

BIOGRAPHIES

HANS HAACKE is a world-renowned artist whose work explores systems and processes, both natural (such as geological and meteorological) and man-made (including governmental and corporate power). Born in Cologne, Germany, in 1936, Haacke received his degree in 1960 from the Staatliche Werkakademie in Kassel, then West Germany, and studied at the Tyler School of Art of Temple University in Philadelphia on a Fulbright Fellowship. In his early work, Haacke's use of earth, air, grass and water was influenced by his involvement in Group Zero, an international group of artists interested in finding new materials with which to make art. Haacke was a Professor of Art at the Cooper Union in New York from 1967 to 2002, and also taught at universities in Seattle, Philadelphia, Hamburg, and Essen, among others. He is the recipient of a fellowship from the John Simon Guggenheim Memorial Foundation, a grant from the National Endowment for the Arts, and the College Art Association's Distinguished Teaching of Art Award and Distinguished Artist Award for Lifetime Achievement. In 1993, Haacke received the Golden Lion (which he shared with Nam June Paik) at the Venice Biennale for *Germania*, his installation for the German Pavilion. Throughout his distinguished career, Haacke has exhibited in numerous solo and group shows around the world. In 2006, he was the subject of a career-long retrospective titled *Hans Haacke: wirklich*, which was shown at the Akademie der Künste in Berlin and the Deichtorhallen in Hamburg. He has participated in several Documenta exhibitions in Kassel and in biennials in New York, Venice, Sydney, São Paulo, Johannesburg, Gwangju in Korea, and most recently Sharjah in the United Arab Emirates. He lives and works in New York City.

CAROLINE A. JONES, Director of the History Theory + Criticism Program and Professor of Art History at MIT, studies modern and contemporary art, with a particular focus on its technological modes of production, distribution, and reception. Prior to completing her PhD at Stanford, she worked at the Museum of Modern Art (1977–83) and the Harvard University Art Museums (1983–85), and completed two documentary films. In addition to these institutions, her exhibitions and/or films have been shown at such venues as the San Francisco Museum of Modern Art, the Smithsonian's Hirshhorn Museum and Sculpture Garden, and the Hara Museum of Contemporary Art in Tokyo. Jones is the recipient of fellowships from the National Endowment for the Humanities and the John Simon Guggenheim Foundation (among others); her books include *Eyesight Alone: Clement Greenberg's Modernism and the Bureaucratization of the Senses* (2005) and *Machine in the Studio: Constructing the Postwar American Artist* (1996/98). She was the co-editor of *Picturing Science, Producing Art* (1998) and the editor of *Sensorium: Embodied Experience, Technology, and Contemporary Art*, which accompanied an exhibition at the MIT List Visual Arts Center in 2006–7. She is currently completing a book on *Desires for the World Picture: The Global Work of Art*.

MIT LIST VISUAL ARTS CENTER STAFF

Karen S. Fegley, Gallery Attendant
Magda Fernandez, Gallery Attendant
David Freilach, Acting Director
Kristin Johnson, Gallery Attendant
Diane Rosenblum Kalik, Fine Arts Registrar
Bryce Kauffman, Gallery Attendant
Mark Linga, Educator, Public Relations Officer
Tim Lloyd, Gallery Manager
John Osorio-Buck, Gallery Assistant
Barbra Pine, Administrative Assistant
João Ribas, Curator
Alise Upitis, Public Art Curator
Suara Welitoff, Gallery Attendant

ADVISORY COMMITTEE

Susan Leff, Chairman	Marjory Jacobson
Ute Meta Bauer	Philip Khoury
Ruth Bowman	Leila Kinney
Suelin Chen	Boris Magasanik
Susan Cohen	Marian Marill
Charles Coolidge	John Melick
Lindsay Coolidge	Andrea Miller-Keller
Jerry Friedman	Andrea Nasher
Susanne Ghez	Anthony T. Podesta
Per Gjorstrup	Stephen Prina
Kitty Glantz	David Solo
Geoffrey L. Hargadon	Jeanne D. Stanton
Jon Hendricks	Martin E. Zimmerman

Opposite: View of Haacke's studio in Cologne with the work *Blue Silk*, 1964.

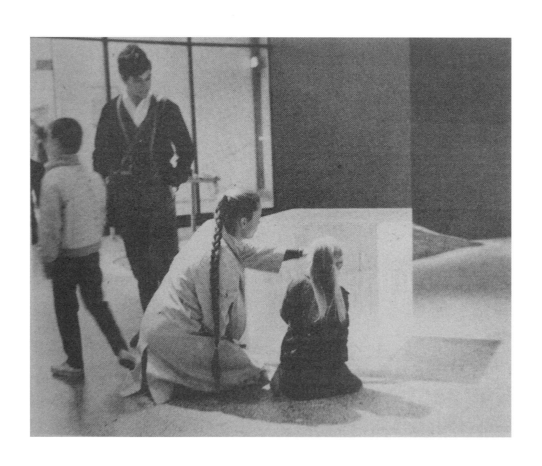